PLEXIGLAS®

Werkstoff in Architektur und Design
Material in Architecture and Design

Kai Buchholz

PLEXIGLAS®

Werkstoff in Architektur und Design
Material in Architecture and Design

Herausgegeben von | Edited by
Ralf Beil, Institut Mathildenhöhe Darmstadt

Wienand Verlag

Inhalt

PLEXIGLAS®
Ein Material macht Geschichte
Vorwort und Dank von Ralf Beil ... 7

 Was ist Acrylglas? ... 11

Einleitung ... 13

 Acrylglas in der Systematik der Kunststoffe ... 15

Brillant und kostbar
Künstliches Glas in den 30er und 40er Jahren ... 17

 Wie wird Acrylglas hergestellt? ... 29

Klar und sauber
Durchblick im Wirtschaftswunder ... 45

 Wie lässt sich Acrylglas verarbeiten? ... 57

Cool Bubbles
Spacedesign für die Blumenkinder ... 69

 Mechanische Eigenschaften ... 81

Postmoderne Spielereien
Die 80er Jahre ... 97

 Optische Eigenschaften ... 107

Bunt und flexibel
Hightech-Werkstoff in der globalisierten Warenwelt ... 113

 Witterungsbeständigkeit ... 125

Glossar ... 137

 Körperverträglichkeit ... 139

Anhang

 Verzeichnis der Exponate ... 141
 Die Leihgeber der Ausstellung ... 149
 Personenregister ... 150
 Foto- und Bildnachweis ... 151

Contents

PLEXIGLAS®
A Material Makes History
Foreword and Acknowledgements by Ralf Beil … 7

 What Is Acrylic? … 11

Introduction … 13

 How Acrylic Fits into the Systematic Classification of Plastics … 15

Brilliant and Precious
Synthetic Glass in the 1930s and 1940s … 17

 How Is Acrylic Manufactured? … 29

All Clear Ahead
for the German Economic Miracle … 45

 How Can Acrylic Be Fabricated? … 57

Cool Bubbles
Spacy Design for Flower Children … 69

 Mechanical Properties … 81

Postmodern Whimsicalities
The 1980s … 97

 Optical Properties … 107

Colorful and Flexible
High Tech Plastic in the Globalized Material World … 113

 Weather Resistance … 125

Glossary … 137

 Physiological Compliance … 139

Appendix

 List of Exhibits … 141
 Lenders of the Exhibition … 149
 Index of Names … 150
 Photo and Image Credits … 151

Drilling Plexiglas

Drills for PLEXIGLAS should be ground with very little "lead" to reduce danger of tearing the plastic.

The new 48-page PLEXIGLAS Fabricating Manual explains this fabricating tip and suggests hundreds of equally valuable shortcuts for speeding the production of PLEXIGLAS military, naval, and defense units.

As pioneers in the field of acrylic plastics, Rohm & Haas is glad to pass along this information so that each piece of PLEXIGLAS can play its full part in the defense program. Write for your copy today.

THE CRYSTAL-CLEAR ACRYLIC PLASTICS

PLEXIGLAS
SHEETS AND RODS

CRYSTALITE
MOLDING POWDER

PLEXIGLAS and CRYSTALITE are the trade-marks, Reg. U. S. Pat. Off., for the acrylic resin thermoplastics manufactured by the Rohm & Haas Company.

This picture graphically illustrates the tremendous importance of permanently transparent PLEXIGLAS in modern aircraft. Through clear PLEXIGLAS sections that are able to withstand the most powerful air pressures, the bombardier of this Douglas bomber enjoys maximum vision in every direction. PLEXIGLAS is aviation's standard transparent plastic.

ROHM & HAAS COMPANY
WASHINGTON SQUARE, PHILADELPHIA, PA.

Manufacturers of Leather and Textile Specialties and Finishes..Enzymes..Crystal-Clear Acrylic Plastics..Synthetic Insecticides..Fungicides..and other Industrial Chemicals

PLEXIGLAS®
Ein Material macht Geschichte
Vorwort und Dank

PLEXIGLAS®
A Material Makes History
Foreword and Acknowledgements

Polymethylmethacrylat (PMMA) ist weit mehr als eine chemische Formel. Es ist Teil einer exemplarischen Firmengeschichte und Erfolgsstory. Wie *Nutella*, *Tempo* oder *Teflon*, um nur drei Beispiele aus dem deutschsprachigen Raum zu nennen, ist der Markenname von PMMA zum Oberbegriff für Acrylglas-Produkte jedweder Couleur und Ausformung geworden: PLEXIGLAS®, in der Darmstädter Röhm & Haas AG entwickelt und von Firmenchef Otto Röhm 1933 patentiert, hat schnell seinen Siegeszug rund um die Welt angetreten. Das vorliegende Katalogbuch und die damit verbundene Ausstellung können deshalb anhand der Geschichte des Materials zugleich Design-, Gesellschafts- und Kulturgeschichte par excellence dokumentieren. Waren es im Zweiten Weltkrieg amerikanische wie deutsche Flugzeugkanzeln, die mit *Plexiglas* ausgestattet wurden, so wird das Material in den Jahren nach 1945 regelrecht zum Spiegel wechselnder Lebenskulturen: vom sprichwörtlichen „Schneewittchensarg" der 50er Jahre – einer Abdeckhaube für Schallplattenspieler – über die „Bubble Chairs" der 60er und das Ökomobil der 80er Jahre zu den „Rainbow"-Sonnenliegen der Freizeitgesellschaft von heute. Stets zeigt die Geschichte des Materials *Plexiglas* Design als Seismograph des Seins. Ausstellung und Publikation sind damit im besten Sinn programmatisch für die auf der Mathildenhöhe Darmstadt anvisierte Kulturproduktion – so wie

Polymethyl methacrylate (PMMA) is far more than a chemical formula: it is part of an exemplary company history and success story. Like *Nutella*, *Tempo* and *Teflon* – to name only three examples from German-speaking countries – PLEXIGLAS®, the trademark for PMMA, has become the generic term for acrylic products of every shape and kind. The material developed at the Darmstadt company Röhm & Haas AG and patented in 1933 by company director Otto Röhm rapidly caught on around the world. The present catalogue and the exhibition to which it refers are therefore excellently positioned to simultaneously document the history of design, society and culture, based on the material's background. Whereas in World War II, American and German aircraft canopies were equipped with *Plexiglas*, after 1945 the material went on to mirror shifting lifestyles, ranging from "Snow White's coffin" in the 1950s (a nickname for a popular German record player cover), the Bubble Chairs of the 1960s and the 1980s Ecomobile to the "Rainbow" sun loungers of today's leisure society. The history of *Plexiglas* reveals time and again that design serves as a seismograph of human culture. The exhibition and publication therefore embody the central principle of cultural production at Mathildenhöhe Darmstadt in the best possible sense, just as the timeframe from the beginning of the 20th century up to today corresponds to the eminent location of Mathildenhöhe, its past and its present.

auch das Zeitfenster vom Anfang des 20. Jahrhunderts bis heute dem Schauplatz Mathildenhöhe, seiner Geschichte und Gegenwart entspricht.

Mein erster Dank geht an die Röhm GmbH: Sie hat Ausstellung und Katalog im Rahmen ihres 100-jährigen Firmenjubiläums ermöglicht. Den Geschäftsführern Gregor Hetzke, Rainer Faß und Michael Müller-Hennig, Franziska Linné von Kommunikation Services sowie Wilfried Tammen vom Eventmanagement gebührt gleichermaßen Dank für ihren Einsatz sowie ihre Begeisterung für dieses Projekt, das das wohl bekannteste Produkt der Unternehmensgeschichte ins rechte Licht rückt.

Allen Leihgebern der Ausstellung, den Designern, Firmen, Museen und Privatsammlern, sei Dank für ihre fundamentale Unterstützung. Michael Wienand war spontan Feuer und Flamme für das Buchprojekt, das von der Lektorin Christine Linder und dem Grafiker Rainer Lienemann kompetent umgesetzt wurde.

Kai Buchholz gilt neben seiner wesentlichen kuratorischen Leistung für das Projekt insbesondere mein Dank für die ebenso präzisen wie kenntnisreichen Texte, die dieses Buch zu einem regelrechten Kompendium für *Plexiglas* machen.

Im Institut Mathildenhöhe geht mein Dank an Renate Ulmer für zahlreiche Vorbereitungsarbeiten sowie an Annette Windisch für ihre umfassende Projektbetreuung. Christian Häussler hat das anspruchsvolle Ausstellungsdesign entworfen, Tim Späth das markante Erscheinungsbild des Projektes geprägt. Von Ulli Emig über Lina Ophoven und Angelika Nitsch bis hin zum Technikerteam unter der Leitung von Jürgen Preusch haben alle MitarbeiterInnen des Instituts auf ihre Weise dieses wunderbare Projekt Realität werden lassen.

Lassen Sie sich nun von Kai Buchholz auf eine spannende Reise durch das „Jahrhundert des Kunststoffs" mitnehmen. Tauchen Sie ein in die vielgestaltige Welt des ebenso leichten wie stabilen, transparent und opak faszinierenden Materials *Plexiglas*.

Ralf Beil
Direktor
Institut Mathildenhöhe Darmstadt

My thanks go firstly to Röhm GmbH, which enabled the exhibition and catalogue as part of its centennial celebrations. Thanks are due in equal measure to Management Board Members Gregor Hetzke, Rainer Faß and Michael Müller-Hennig, to Franziska Linné from Communication Services and to Wilfried Tammen from Event Management for their commitment and their passion for this project, which places the company's best-known product in a fitting light.

I would like to thank everyone who has loaned exhibits – designers, companies, museums and private collectors – for their fundamental contributions. Michael Wienand was immediately full of enthusiasm for the book project, which was expertly implemented by editor Christine Linder and graphic designer Rainer Lienemann.

I owe my thanks to Kai Buchholz, both for his essential curatorship of the project and especially for his precise and knowledgeable texts that make this book a real compendium of *Plexiglas*.

At the Institut Mathildenhöhe, my thanks go to Renate Ulmer for copious preparatory work and Annette Windisch for her comprehensive project management. Christian Häussler drafted the exclusive design of the exhibition, Tim Späth created the project's striking graphic representation. Ulli Emig, Lina Ophoven and Angelika Nitsch, together with the team of technicians headed by Jürgen Preusch, stand for all the staff of the institute who helped in their various ways to turn this wonderful project into reality.

And now let Kai Buchholz take you on an exciting journey through the "century of plastics." Immerse yourself in the vast and varied world of lightweight yet robust, transparent and opaque, ever fascinating *Plexiglas*.

Ralf Beil
Director
Institute Mathildenhöhe Darmstadt

Converted blister forms receptacle for growing plant and adds an unusual note to this coffee table

War-Plane Blisters in Peace-Time Use

Another table using an acrylic dome has transparent top which shows plant off to good advantage

FROM a B-29 ready for action in enemy skies to the restful interior of a modern home is a big jump, but one which has been successfully accomplished by blown acrylic domes. An ex-Air Force sergeant who was assigned to B-29s during the war has taken surplus blisters and converted them into ultra-modern coffee tables. Some are also giant fishbowls; others contain plants to add an outdoor note to a living room. Two of the latter are illustrated above. One has a transparent top through which the decorative plant beneath can be seen. The other has a square wooden top with the center cut out to allow the plant to grow freely above the table.

Tropitan and other unusual woods are used in combination with the blisters to form a variety of designs. The furniture is being manufactured by Tropicmode Furniture Co., Hollywood, Calif.; the blisters used were blown from Lucite or Plexiglas sheets by the Swedlow Plastics Co., Los Angeles, Calif., for the Armed Forces during the war.

Durable, easy to clean

The qualities required of the plastic domes for use in airplanes give them additional advantages in their present use. Special care was taken to make them optically clear and exceptionally strong. This strength means long wear without danger of breaking from accidental kicks or blows in the home. Easy to clean, the domes can be kept scratch-free by occasional waxing.

Was ist Acrylglas?

Die materielle Umwelt des Menschen baut sich aus →Atomen und Atomverbindungen, so genannten →Molekülen, auf. Acrylglas ist ein transparenter Kunststoff, dessen Moleküle aus Atomen von →Kohlenstoff (C), →Wasserstoff (H) und →Sauerstoff (O) zusammengesetzt sind. In der Chemie bezeichnet man Acrylglas als Polymethylmethacrylat (PMMA), wobei die Vorsilbe „poly" anzeigt, dass dieser Stoff aus vielgliedrigen, unterschiedlich langen Ketten des Moleküls Methylmethacrylat (MMA) besteht. Seine Strukturformel lautet:

What Is Acrylic?

The material world around us consists of →atoms and groups of atoms, known as →molecules. Acrylic is a transparent plastic whose molecules are composed of →carbon (C), →hydrogen (H) and →oxygen (O) atoms. The chemical name for acrylic is polymethyl methacrylate (PMMA). The prefix "poly" indicates that this material is made up of chains of different length with repeating units of the molecule methyl methacrylate (MMA). Its structural formula is:

$$\left[\begin{array}{c} \\ -CH_2-C(CH_3)(COOCH_3)- \\ \end{array} \right]_n$$

Der kleine Buchstabe *n* an der eckigen Klammer macht abkürzend deutlich, dass sich links und rechts von den beiden mittleren C-Atomen weitere gleichartige Moleküle variabler Anzahl (n) anschließen. Die Länge dieser Molekülketten hat Einfluss auf die physikalischen Eigenschaften des jeweiligen Acrylglases: Je länger die Ketten, desto stabiler und chemikalienbeständiger ist der Werkstoff. Sortenreine Acrylglasabfälle können gemahlen und vollständig recycelt werden, was angesichts knapper werdender Ressourcen ein entscheidender Vorteil ist.

The small letter *n* next to the angle bracket signifies that further molecules of identical nature and variable number (n) are attached to the left and right of the two middle C-atoms. The length of these molecular chains has an influence on the physical properties of the given grade of acrylic. The longer the chains, the more stable and chemical-resistant the material. Acrylic scrap that has been separated from other material can be reground and completely recycled, a crucial advantage in view of our dwindling resources.

Einleitung
Introduction

Im Unterschied zu Tier und Pflanze muss sich der Mensch künstliche Umwelten schaffen, um überleben zu können; damit tritt er aus der Natur heraus und wird zum Schöpfer von Kultur. Die philosophische Anthropologie weist an dieser Stelle darauf hin, dass der Mensch nicht nur das vernunftbegabte Lebewesen (*homo sapiens*), sondern auch das herstellungsbegabte (*homo faber*) ist.[1] Seine produktiven Fertigkeiten haben sich im Laufe der Zeit in solchem Maße entwickelt und verfeinert, dass man angesichts minutiös gearbeiteten Schmucks, raffinierter Möbel und hochmoderner intelligenter Maschinen heute von einer enorm ausgefeilten Herstellungskultur sprechen kann, die weit über das Lebensnotwendige hinausreicht.[2] Grundlage aller Artefakte sind Stoffe (z. B. Marmor, Gummi, Eichenholz, Gold, Nylon, Smaragde), die durch manuelle oder maschinelle Bearbeitung eine neue, den menschlichen Wünschen und Bedürfnissen angepasste Form erhalten. Im Gebrauch tritt die blanke Stofflichkeit allerdings meist hinter der Zweckfunktion und dem ästhetischen Gesamteindruck zurück.[3] Hinzu kommt, dass die wenigsten Menschen angesichts der mittlerweile zahllosen speziellen Verarbeitungstechniken eine angemessene Vorstellung davon haben, wie sich die Wege vom Rohstoff zum fertigen Gebrauchsgegenstand im Einzelnen vollziehen. Ein exemplarischer Blick auf diese Zusammenhänge ist aber besonders wertvoll, fördert er doch das eigene Wahrnehmungsvermögen und die praktische Urteilsfähigkeit. Gerade in der komplizierten Welt von heute lohnt es, Materialien und ihre unterschiedlichen Formgebungsmöglichkeiten näher ins Auge zu fassen.

Am Beispiel des Werkstoffs Acrylglas – besser bekannt unter dem Markennamen PLEXIGLAS® – wird hier gezeigt, wie technisches Wissen, künstlerische Kreativität und praktisch-kulturelle Zielsetzungen bei der Umge-

Unlike plants and animals, man needs to create artificial environments in order to survive. In this, he transcends nature and becomes a creator of culture. As philosophical anthropology points out, man is not only the rational animal (*homo sapiens*), but also the maker and user of tools (*homo faber*).[1] Over the course of time, his productive skills have become highly developed and refined, giving rise to an enormously sophisticated manufacturing culture that comprises intricately worked jewelry, elaborate furniture and ultramodern, intelligent machines. Nowadays, this culture extends far beyond the level strictly necessary for survival.[2] The basis for all these artifacts are materials (e. g. marble, rubber, oak, gold, nylon, emeralds), which are shaped by machines or by hand in line with human desires and requirements. In everyday use, though, the material itself is usually eclipsed by the intended function and the overall aesthetic impression.[3] Most people, in fact, have only the vaguest idea how raw materials are really transformed into finished commodities. Given the innumerable special fabrication techniques that exist today, this is hardly surprising. Yet it is well worthwhile taking a look at some of these processes to enhance our own powers of perception and discernment. Particularly in our complicated modern world, it is rewarding to look more closely at materials and the various possibilities of forming them.

In this catalogue, we take the example of acrylic – better known by the PLEXIGLAS® trademark – to show how technical know-how, artistic creativity and practical, cultural objectives come together to remodel the world we live in. We examine how chemical and creative processes and changing ideals interact and give rise to a plethora of cultural connections.[4] The special attention which this noblest of plastics deserves is also evidenced by the great interest it has aroused among sculptors like Naum Gabo, Enrico Baj and Vera Röhm.[5]

staltung unserer Lebenswelt ineinandergreifen, wie sich chemische Verfahren, anspruchsvolle Gestaltungsprozesse und wandelnde Lebensideale gegenseitig durchdringen und verschiedenste Kulturzusammenhänge entstehen lassen.[4] Dass dieser edelste aller Kunststoffe besondere Aufmerksamkeit verdient, belegt nicht zuletzt das große Interesse, das ihm bildende Künstler wie Naum Gabo, Enrico Baj und Vera Röhm entgegengebracht haben.[5]

Anmerkungen

1 Vgl. z. B. Wilhelm Kamlah: Philosophische Anthropologie. Mannheim, Wien, Zürich 1973. S. 33: „Der redend und sehend vorausblickende Mensch ist nicht nur das Lebewesen, das Sprache hat, sondern auch das Lebewesen, das *Geräte* herstellt und verwendet, homo faber. ›Ansätze‹ von Werkzeuggebrauch und Geräteherstellung gibt es auch bei Tieren. Aber nur der redende Mensch kann vorausblickend Geräte entwerfen, verändern, für wechselnde Zwecke einsetzen."

2 Vgl. z. B. Paul Lorenzen: Lehrbuch der konstruktiven Wissenschaftstheorie. Mannheim, Wien, Zürich 1987. S. 177–227; Peter Janich: Grenzen der Naturwissenschaft. München 1992. S. 197–213.

3 Zum ästhetischen Eigenwert von Materialien vgl. z. B. Thomas Raff: Die Sprache der Materialien. Anleitung zu einer Ikonologie der Werkstoffe. München 1994; Gernot Böhme: Inszenierte Materialität. In: Daedalos. 56 (1995). S. 36–43; Dieter Mersch: Deutsche Materialästhetik. In: Die Lebensreform. Hg. K. Buchholz, R. Latocha, H. Peckmann, K. Wolbert. Bd. 1. Darmstadt 2001. S. 267–269.

4 Zur kulturellen Rolle der Chemie vgl. in diesem Zusammenhang Peter Janich: Grenzen der Naturwissenschaft. München 1992. S. 63–85; Ders.: Protochemie. Programm einer konstruktiven Chemiebegründung. In: Ders.: Konstruktivismus und Naturerkenntnis. Auf dem Weg zum Kulturalismus. Frankfurt a. M. 1996. S. 237–258.

5 Vgl. z. B. Anca Arghir: Transparenz als Werkstoff. Acrylglas in der Kunst. Köln 1988; Vera Röhm. Köln 2007.

Notes

1 See for example Wilhelm Kamlah, *Philosophische Anthropologie* (Mannheim, Vienna, Zurich: Bibliographisches Institut, 1973), p. 33: "Man, with his verbal and visual prescience, is not only the user of articulate language, but also the maker and user of *implements*, homo faber. Animals too show 'rudimentary signs' of using tools and making implements. But only man, the talking animal, employs foresight to design and modify implements for changing purposes." (courtesy translation from German)

2 See for example Paul Lorenzen, *Lehrbuch der konstruktiven Wissenschaftstheorie* (Mannheim, Vienna, Zurich: Bibliographisches Institut, 1987), p. 177–227; Peter Janich, *Grenzen der Naturwissenschaft* (Munich: Beck, 1992), pp. 197–213.

3 On the intrinsic aesthetic value of materials, see for example Thomas Raff, *Die Sprache der Materialien*, Anleitung zu einer Ikonologie der Werkstoffe (Munich: Deutscher Kunstverlag, 1994); Gernot Böhme, "Inszenierte Materialität," *Daedalos* 56 (1995): 36–43; Dieter Mersch, "Deutsche Materialästhetik," in *Die Lebensreform*, ed. Kai Buchholz, Rita Latocha, Hilke Peckmann, Klaus Wolbert, Vol. 1 (Darmstadt: Häusser, 2001), pp. 267–269.

4 On the cultural role of chemistry, in this context see Peter Janich, *Grenzen der Naturwissenschaft* (Munich: Beck, 1992), pp. 63–85; "Protochemie, Programm einer konstruktiven Chemiebegründung," in *Konstruktivismus und Naturerkenntnis*, Auf dem Weg zum Kulturalismus (Frankfurt a. M.: Suhrkamp, 1996), pp. 237–258.

5 See for example Anca Arghir, *Transparenz als Werkstoff*, Acrylglas in der Kunst (Cologne: Wienand, 1988); Vera Röhm (London: Reaktion Books, 2006).

Acrylglas in der Systematik der Kunststoffe

Seit Jahrtausenden verwendet der Mensch zur Herstellung von Gebrauchsgegenständen Rohstoffe, die er in der Natur vorfindet – etwa Stein, Holz oder Horn. Durch die Fortschritte der modernen Technik ist es gelungen, diese natürlichen Quellen für die Erzeugung zusätzlicher Werkstoffe zu nutzen. So haben die Erkenntnisse der Organischen Chemie den Menschen in die Lage versetzt, aus Steinkohleteer – später auch aus Erdöl und Kohle – eine vielgestaltige Familie völlig neuartiger Materialien hervorzubringen. Diese Kunststoffe bestehen aus Makromolekülen oder →Polymeren und lassen sich in drei große Gruppen einteilen: Diejenigen, die ein dem Kautschuk vergleichbares, gummiartiges Verhalten zeigen (z. B. Buna), werden Elastomere genannt. Als Duroplaste bezeichnet man dagegen feste Kunststoffe, die auch bei hohen Temperaturen formbeständig sind, sich aber zersetzen, anstatt zu schmelzen. Viele von ihnen – so zum Beispiel die Phenolharze (PF), die Harnstoffharze (UF) und die Melaminharze (MF) – entstehen durch die Verbindung mit Formaldehyd. Die dritte Gruppe bilden die Thermoplaste: Kunststoffe, die bei Erhitzung weich und verformbar werden und nach Abkühlung wieder erhärten, ohne ihre chemische Struktur zu verändern. Zu den Thermoplasten, die heute den Hauptanteil der Kunststoffproduktion ausmachen, zählen neben dem Acrylglas oder →Polymethylmethacrylat (PMMA) unter anderem auch die Polyamide (PA), der Polyester (PET), das Polyethylen (PE), das Polypropylen (PP), das Polycarbonat (PC), das Polyvinylchlorid (PVC) und das Polystyrol (PS). Gegenüber anderen Materialien wie zum Beispiel Metall zeichnen sich die Kunststoffe durch Korrosionsbeständigkeit, gute Isoliereigenschaften sowie leichte Form- und Färbbarkeit aus.

How Acrylic Fits into the Systematic Classification of Plastics

For thousands of years, man has used the raw materials found in nature (stone, wood or horn) to make everyday implements. The progress in modern technology has made it possible to use these natural sources to create additional materials. Findings in organic chemistry, for instance, have allowed us to produce a huge variety of novel materials from coal tar, and later also from petroleum and coal. These synthetic materials consist of macromolecules or →polymers and can be classed in three major groups: those with flexible, rubber-like behavior (e.g. Buna) are termed elastomers. Solid plastics that are dimensionally stable at high temperatures and decompose rather than melt are termed thermosets. Many of these, like phenolic resins (PF), urea resins (UF) and melamine resins (MF), form upon combination with formaldehyde. The third group consists of thermoplastics, which become soft and pliable when heated and harden upon cooling without changing their chemical structure. Most of the plastics manufactured today are thermoplastics and include acrylic, or →polymethyl methacrylate (PMMA) as well as the polyamides (PA), the polyesters (PET), polyethylene (PE), polypropylene (PP), polycarbonate (PC), polyvinyl chloride (PVC) and polystyrene (PS). Plastics are distinguished from other materials such as metal by their corrosion resistance, good insulating properties and their aptitude for forming and coloring.

Brillant und kostbar
Künstliches Glas in den 30er und 40er Jahren

Brilliant and Precious
Synthetic Glass in the 1930s and 1940s

Mit Nachdruck widmet sich die Röhm & Haas AG in Darmstadt ab 1928 der Erzeugung von Acrylglas, eines glasartigen Kunststoffes, der unter Wärme geformt und im festen Zustand wie Holz oder Metall bearbeitet werden kann.[1] Als 1933 die Patentreife erreicht ist, lässt Firmenchef Otto Röhm das neue Material unter dem Namen PLEXIGLAS® ins Markenregister eintragen und begibt sich auf die Suche nach geeigneten Anwendungsmöglichkeiten.

Da sich das künstliche Glas als sehr steif und hoch transparent erweist, gleichzeitig aber um ein Mehrfaches bruchfester als Silikatglas, ist es nahe liegend, zunächst Verwendungsformen zu erkunden, die denjenigen des anorganischen Glases ähneln. So beauftragt Röhm die Herstellung von Brillengläsern aus Acrylglas und lässt die Glasscheiben seines Automobils durch Scheiben aus dem neu entwickelten Material ersetzen. Tatsächlich konzentriert sich die Verwendung von Acrylglas, das auch in anderen Ländern rasch Verbreitung findet, bis in die 40er Jahre auf derartige technische Bereiche: Während des Zweiten Weltkriegs fließt der Löwenanteil der deutschen und amerikanischen Acrylglasproduktion

From 1928, Röhm & Haas AG in Darmstadt concentrated its efforts on producing acrylic, a glass-like plastic that can be thermoformed and, in its solid state, machined like wood or metal.[1] Once it had been brought to patent stage in 1933, the company's director Otto Röhm had the new material registered under the PLEXIGLAS® trademark, and began to look for suitable applications.

As the synthetic material proved to be extremely rigid and highly transparent but was far less breakable than silicate glass, the first step was obviously to examine whether it could be used in a similar way to inorganic glass. Röhm accordingly commissioned spectacle lenses to be made from acrylic, and had the glass windows of his car replaced with sheets of the new material. Well into the 1940s, when acrylic had become widely accepted in other countries too, the main applications centered on technical fields of this nature. During World War II, most of the acrylic produced in Germany and the USA went into the fabrication of aircraft canopies for fighter planes.[2] In this glazing, the synthetic material known by its chemical abbreviation PMMA was vastly superior to silicate glass, being much lighter and less prone to breakage. In 1935, during the Bayreuth Festival, Winifred Wagner's excellent contacts with Nazi régime leaders resulted in the first orders from the German Luftwaffe for acrylic from Röhm & Haas AG. The company showed its gratitude by having a dove specially made from acrylic, one of the first objects to be crafted from a *Plexiglas* block. Brilliantly lit, it appeared

Schlafzimmer von Helena Rubinstein mit Möbeln aus *Lucite*, 1940
Helena Rubinstein's bedroom with furniture made of *Lucite*, 1940
Entwurf | Design: Ladislas Medgyès

in die Fertigung von Kanzeln für Jagdflugzeuge.² Hier ist das künstliche Material, das in der Chemie abkürzend als PMMA bezeichnet wird, wegen seiner Leichtigkeit und Bruchsicherheit dem Silikatglas eindeutig überlegen. Als während der Bayreuther Festspiele 1935 dank Winifred Wagners glänzender Kontakte zu den Machthabern des NS-Staates Aufträge der Luftwaffe zu Stande kommen, revanchiert sich die Röhm & Haas AG mit einer eigens hergestellten Taube – einem der ersten Gegenstände aus *Plexiglas* in Blockform. Brillant erleuchtet, erscheint sie 1936 in der Schlussszene der Bayreuther Parsifal-Inszenierung.³

1935 betraut Röhm den Leiter des firmeneigenen Kammerorchesters anlässlich einer Betriebsfeier damit, eine Violine aus *Plexiglas* anzufertigen. Nach zähem Ringen gelingt das Experiment, und Röhm kann später bei seinen Berlin-Aufenthalten mit Freude den Dachgarten des Hotels Eden besuchen, wo ein Streichquartett

in the final scene of "Parsifal", at the 1936 performance in Bayreuth.³

In 1935, during a company celebration, Röhm commissioned the conductor of the company's own chamber orchestra to build a violin from *Plexiglas*. After strenuous efforts, the experiment was successful, and later, when on business in Berlin, Röhm was able to enjoy music performed on acrylic instruments by a string quartet that played on the roof terrace of Hotel Eden. Simultaneously, the Mönnig company in Markneukirchen crafted a complete set of wind instruments from the synthetic glass.⁴ Whereas the string instruments were only suitable for chamber music because of the novel material's poor resonance, the flutes and clarinets had all the acoustic attributes of their classical wood or metal counterparts. They became very popular with military bands.⁵ And finally, at the 1937 World's Fair in Paris, Röhm & Haas presented the use of PMMA in instrument building with resounding success.

„Als einer der schönsten Kunststoffe überhaupt ermöglicht Polymethylmethacrylat eine vielseitige Bandbreite dekorativer und nützlicher Funktionen." John Gloag

auf Acrylglasinstrumenten musiziert. Gleichzeitig entwickelt die Firma Mönnig in Markneukirchen aus dem künstlichen Glas einen vollständigen Satz von Holzblasinstrumenten.⁴ Während sich die Streichinstrumente wegen der schwachen Resonanzfähigkeit des neuen Werkstoffs nur für Kammermusik eignen, weisen die Flöten und Klarinetten im Vergleich zu klassischen Holz- oder Metallinstrumenten keinerlei akustische Nachteile auf. Im Gegenteil – auch bei Militärkapellen erfreuen sie sich großer Beliebtheit.⁵ Mit durchschlagendem Erfolg präsentiert Röhm & Haas die Verwendung von PMMA im Instrumentenbau schließlich 1937 auf der Pariser Weltausstellung.

Weitere frühe Anwendungen des transparenten Materials finden sich im Möbelbau, in der Schmuckherstellung und in der Fertigung von Damenhandtaschen. Betrachtet man diese Acrylglasprodukte unter ästhetischen Gesichtspunkten, fällt auf, dass den neuen, klaren Kunststoff in der damaligen Vorstellungswelt ein Hauch edler

Further early applications for the transparent material were furniture, jewelry and ladies' handbags. From an aesthetic viewpoint, it is evident that the new, crystal-clear plastic had a distinctive and prestigious cachet in the collective imagination of that period. In the USA, transparent ladies' handbags seemed to have come straight from the fairytale world of glass slippers and gilded carriages. Intricately engraved brooches, bracelets and earrings, and items of tableware with a sterling silver rim lent an aura of enchantment to the material at the end of the 1930s.

In the world of interior design, transparent PMMA underwent two different parallel developments. The furniture designed by Lorin Jackson for Grosfeld House, or the bedroom furniture that Ladislas Medgyès designed in 1940 for Helena Rubinstein followed traditional wooden role models. With its ethereal appearance, it had a similar effect to the acrylic jewelry and handbags. Occasionally, due to her ailing health, Ms. Rubinstein also received members of staff in her transparently furnished bedchamber. One of them, her personal assistant Patrick O'Higgins, recalls:

Volkswagen-Modell aus *Plexiglas*, Automobilausstellung Berlin, 1937
Volkswagen model made of *Plexiglas*, Automobile Exhibition Berlin, 1937

Kostbarkeit umgibt. In den USA verströmen durchsichtige Damenhandtaschen einen ähnlichen magischen Reiz wie gläserne Pantoffeln aus der Märchenwelt. Auch sorgfältig gravierte Broschen, Armbänder und Ohrringe sowie mit wertvollem Silberrand verzierte Geschirrteile aus Acrylglas verleihen dem Material Ende der 30er Jahre eine zauberische Aura.

In der Innenarchitektur werden mit transparentem PMMA parallel zwei unterschiedliche Wege eingeschlagen. Die Möbel von Lorin Jackson für den Hersteller Grosfeld House oder die Schlafzimmereinrichtung, die Ladislas Medgyès 1940 für Helena Rubinstein entwirft, orientieren sich an traditionellen Vorbildern aus Holz und erzielen durch ihr immaterielles Erscheinungsbild eine ähnliche Wirkung wie die erwähnten Schmuckstücke

"She pointed to one of several high-backed chairs made of the same transparent material as her bed. The sun's reflections seemed to illuminate Madame and her bed with subtle, incandescent light. Then I realized, with a start, that the curved head and foot boards were actually lit by fluorescent bulbs. I must have nervously examined the chair Madame pointed to, wondering if it would hold my weight, because, as if reading my thoughts, she said: 'Perfectly safe! Lucite! Same stuff as our powder boxes.'"[6]

With a touch of hauteur, some design critics relegated this eccentric furniture to the ranks of substitute or imitation material.[7] As early as 1900, fastidious designers like Henry van de Velde had advocated recognizing the design potential of new materials and making sure to fabricate them according to their nature, rather than treating them as inexpensive or easy-to-use replacements for other materials.[8] Design historian John Gloag now applied this principle to the new plastics and wrote in his 1945 book "Plastics and Industrial Design": "I have seen some experimental types of furniture made from various plastics, which disclosed the absence of a designer or the laziness of a designer,

und Handtaschen. In ihrem durchsichtig möblierten Schlafgemach empfängt Rubinstein aus gesundheitlichen Gründen gelegentlich auch Mitarbeiter. Einer von ihnen, ihr persönlicher Assistent Patrick O'Higgins, erinnert sich: „Sie zeigte auf einen von mehreren hochlehnigen Stühlen aus demselbem transparenten Material wie ihr Bett. Das Sonnenlicht schien Madame und ihr Bett in einen zart glühenden Schimmer zu hüllen. Dann stellte ich überrascht fest, dass die geschwungenen Kopf- und Fußenden tatsächlich mittels fluoreszierender Lampen erstrahlten. Ich muss den Stuhl, den Madame mir anwies, mit sorgenvoller Miene betrachtet haben, mich fragend, ob er wohl mein Gewicht aushalten würde, denn, als ob sie meine Gedanken lesen würde, sagte sie: ›Vollkommen sicher! Lucite! Dasselbe Material wie unsere Puderdosen.‹"[6]

Von einigen Designkritikern werden diese exzentrischen Möbelentwürfe mit herablassendem Unterton in die Tradition der materialimitierenden Surrogate ein-

if indeed one was employed. In some examples, chairs of traditional forms had been made in a transparent plastic, so that shimmering ghosts of Queen Anne or Chippendale models had unhappily materialised. ... Such things could only be produced by people who were still in the 'substitute' stage of thinking about plastics."[9]

The garden chairs consisting of angular steel frames and green plastic sheets with sweeping curves, displayed by Jean Prouvé and Jacques André at the pavilion of the "Union des Artistes Modernes" at the World's Fair in Paris, created an entirely different impression to the furniture derided by Gloag.[10] Combined with cold steel, in this furniture

Lutz-Quartett in der Ufa-Wochenschau, 1937
Lutz quartet appearing in Ufa newsreel, 1937

Schmuck aus *Plexiglas*
Jewelry made of *Plexiglas*

geordnet.⁷ Bereits um 1900 hatten sich anspruchsvolle Entwerfer wie Henry van de Velde dafür ausgesprochen, neu entwickelte Werkstoffe als gestalterisches Potential zu erkennen und bei ihrer Verarbeitung auf eine materialgerechte Formgebung zu achten, anstatt sie als kostengünstigen oder verarbeitungsfreundlichen Ersatz für andere Materialien zu behandeln.⁸ Diese Forderung überträgt der Designhistoriker John Gloag jetzt auch auf die neuen Kunststoffe. So schreibt er 1945 in seinem Buch „Plastics and Industrial Design": „Ich habe einige Möbelprototypen aus verschiedenen Kunststoffen kennen gelernt, die entweder das Fehlen eines Designers

the clean contours of the acrylic express futuristic clarity rather than crystalline mystery. The furniture assembled from geometric acrylic elements used by artist Domenico Mortellito to fit out his New York apartment in 1940 has a similar effect.[11]

Several small contemporary objects made from PMMA, such as cosmetic trays or radio sets, were designed along the same sober and modern lines, but these items were usually made from opaque material. They typify the attempt to lend a characteristic physiognomy to plastic items. Not surprisingly, many of them adhere closely to art déco. Between 1927 and 1932, the use of serial molding techniques

"One of the most beautiful of all plastics, polymethyl methacrylate has a versatile range of decorative and utilitarian functions."

John Gloag

verrieten oder, wenn ein Designer angestellt war, dessen Faulheit bekundeten. In einigen Fällen waren traditionell gestaltete Stühle in durchsichtigem Kunststoff ausgeführt worden, in denen sich flimmernde Geister von Queen-Anne- oder Chippendale-Modellen unheilvoll zu materialisieren schienen. ... Solche Dinge konnten nur von Leuten hergestellt werden, die sich in ihrem Nachdenken über Kunststoffe noch auf der Surrogat-Stufe befanden."⁹

Im Vergleich zu den von Gloag verhöhnten Möbeln vermitteln die Gartensessel aus kantigen Stahlgestellen und fließend gebogenen, grün eingefärbten Kunststoffplatten, die Jean Prouvé und Jacques André im Pavillon der Union des Artistes Modernes auf der Pariser Weltausstellung zeigen, einen völlig anderen Eindruck.[10] In Verbindung mit einem kalten Material erzeugen die schlichten Konturen des Acrylglases hier nicht kristallenes Geheimnis, sondern futuristische Klarheit. Eine vergleichbare Anmutung besitzen die aus geometrischen Acrylglas-Elementen zusammengefügten Möbel, mit denen der Künstler Domenico Mortellito 1940 sein New Yorker Apartment ausstattet.[11]

Auch einige Kleinobjekte aus PMMA wie Kosmetik-Tabletts oder Radiogeräte zeigen zeitgleich ein sachlich-modernes Formenvokabular. Allerdings sind diese Gegenstände meist aus durchgefärbtem Material hergestellt –

specifically adapted to plastic had a crucial influence on the aesthetic forms favored by this art movement.[12] The same applies to the Streamline movement launched by industrial designers like Norman Bel Geddes and Raymond Loewy, with aerodynamic shapes that were meant to encourage consumption in the face of the Great Depression. Streamline chose its means of expression very skillfully to suggest the utopia of a carefree, modern future, besides exerting the eternal attraction of all that is novel.[13] Advanced by the automation of the injection molding process, plastics played a central role in this context. At the same time, with their unlimited formability they represent the universal material for the ideal world of tomorrow.[14]

Messestand von Rohm & Haas, Weltausstellung New York, 1939
Rohm & Haas tradeshow booth, World's Fair New York, 1939

PLEXIGLAS
CRYSTALITE
THE CRYSTAL CLEAR PLASTICS

anschauliche Beispiele für den Versuch, Kunststoffartikel mit einer materialtypischen Physiognomie zu versehen. Es verwundert nicht, dass viele von ihnen dem Art déco verhaftet sind, auf dessen Formästhetik die Anwendung kunststoffspezifischer serieller Presstechniken in den Jahren zwischen 1927 und 1932 entscheidenden Einfluss nimmt.[12] Gleiches gilt für die von Industriedesignern wie Norman Bel Geddes und Raymond Loewy entwickelte Stilform des Streamline, die in der 1929 einsetzenden Weltwirtschaftskrise mit windschnittiger Optik zum Konsum anregen soll. Die Ausdrucksqualitäten des stromlinienförmigen Stils sind außerordentlich geschickt gewählt, da sie nicht einfach durch den Reiz des Neuartigen bestechen, sondern gezielt die Utopie einer sorgenfreien modernen Zukunft suggerieren.[13] Beflügelt von der Automatisierung des Spritzgießverfahrens spielen die Kunststoffe in diesem Zusammenhang eine zentrale Rolle. In ihrer grenzenlosen Formbarkeit verkörpern sie gleichsam den universellen Baustoff für die herbeigesehnte Idealwelt von morgen.[14]

Douglas-Bomber mit Kanzel aus *Plexiglas*, um 1942
Douglas bomber plane with canopy of *Plexiglas*, ca. 1942

Mitglieder einer Militärkapelle in NS-Uniform mit Piccoloflöten aus *Plexiglas*, um 1940
Members of a military band in Nazi uniform with *Plexiglas* piccolos, ca. 1940

Anmerkungen

1 Zur Entwicklung von Acrylglas vgl. Siegfried Heimlich: Porträts in Plastik. Pioniere des polymeren Zeitalters. Darmstadt 1998. S. 63–70; Rudolf Gäth: Streiflichter aus der Geschichte der Kunststoff-Chemie. In: Kunststoffe – ein Werkstoff macht Karriere. Hg. W. Glenz. München, Wien 1985. S. 39–41; Ernst Trommsdorff: Dr. Otto Röhm. Chemiker und Unternehmer. Düsseldorf, Wien 1984. S. 187–236; Jeffrey L. Meikle: American Plastic. A Cultural History. New Brunswick/N. J. 1995. S. 85–89; Susan Mossman: Perspectives on the history and technology of plastics. In: Early Plastics. Perspectives, 1850–1950. Hg. S. Mossman. London 1997. S. 59; Sheldon Hochheiser: Rohm and Haas. History of a Chemical Company. Philadelphia/Pa. 1986.

2 Vgl. Ernst Trommsdorff: Dr. Otto Röhm. Chemiker und Unternehmer. Düsseldorf, Wien 1984. S. 253/254; Jeffrey L. Meikle: American Plastic. A Cultural History. New Brunswick/N. J. 1995. S. 88; 157/158; Susan Mossman: Perspectives on the history and technology of plastics. In: Early Plastics. Perspectives, 1850–1950. Hg. S. Mossman. London 1997. S. 60.

3 Vgl. dazu Günter Lattermann: Die Bayreuther Parsifaltaube von 1935/36. Erscheint in: e-plastory. Zeitschrift für Kunststoffgeschichte.

4 Vgl. Ernst Trommsdorff: Dr. Otto Röhm. Chemiker und Unternehmer. Düsseldorf, Wien 1984. S. 239; Rainer Klitzsch: *Plexiglas* macht Musik transparenter. In: Röhm Spektrum. 39 (1991). S. 34–41.

5 Insbesondere bei deutschen Militärmusikcorps des Afrika-Feldzugs sind Blasinstrumente aus *Plexiglas* begehrt, da sich diese bei hohen Temperaturen weniger stark ausdehnen als Holzinstrumente und sich bei hoher Luftfeuchtigkeit nicht verziehen können. Zudem kommt die Verwendung von PMMA an dieser Stelle den Autarkiebestrebungen des nationalsozialistischen Regimes entgegen, da sie den Import von Edelhölzern aus dem Ausland vermeiden hilft. Vgl. dazu die handschriftlichen Aufzeichnungen von Rainer Klitzsch über mündliche Auskünfte von Joachim Spranger (Erlbach) und Wilhelm Mönnig (Markneukirchen) im Archiv der Röhm GmbH, Darmstadt, 6.2.20, Mappe „Blasinstrumente".

6 Übersetzt nach Patrick O'Higgins: Madame. An Intimate Biography of Helena Rubinstein. New York 1971. S. 59.

7 Vgl. Jean O. Reinecke: Design dates your product. In: Modern Plastics. 15 (1937), Heft 2. S. 122/123; Kai Buchholz: Imitationen – Mehr Schein als Sein? In: Im Designerpark. Hg. K. Buchholz, K. Wolbert. Darmstadt 2004. S. 82–87.

8 Vgl. z. B. Henry van de Velde: Prinzipielle Erklärungen. In: Ders.: Kunstgewerbliche Laienpredigten. Leipzig 1902. S. 165/166: „Sobald heute ein neues Material erfunden oder entdeckt ist, fragt man sich sogleich, welches der schon vorhandenen Materialien das neue am besten imitieren könnte: Stuck, Zement, Zelluloid und Linoleum kommen dabei in Betracht. Wenn man sich aber im Gegenteil fragte, ob das neue Material nicht die alten ersetzen könnte, und welchen neuen unbefriedigten Bedürfnissen es entspräche, so müsste diese Frage nur berechtigt erscheinen, und das Ergebnis dessen, um was es sich handelt, würde so seine Bestimmung auf normale Weise verfolgen, indem es die allgemein hervorgebrachten Formen durch noch nicht existierende bereichert. ... Das Material, welches man für die Imitation wählt, ist an sich nicht hässlich, und ein jedes trägt Spuren einer besonderen Schönheit in sich, welche uns vielleicht für immer verschleiert bleiben wird."

9 Übersetzt nach John Gloag: Plastics and Industrial Design. London 1945. S. 50.

Helena Rubinstein in ihrem Acrylglas-Bett, 1941
Helena Rubinstein in her acrylic bed, 1941

Gartenmöbel, Weltausstellung Paris, 1937
Garden furniture, World's Fair Paris, 1937
Entwurf | Design: Jacques André, Jean Prouvé

Notes

1 On the development of acrylic see Siegfried Heimlich, *Porträts in Plastik*, Pioniere des polymeren Zeitalters (Darmstadt: Verlag Hoppenstedt, 1998), pp. 63–70; Rudolf Gäth, "Streiflichter aus der Geschichte der Kunststoff-Chemie," in *Kunststoffe – ein Werkstoff macht Karriere*, ed. Wolfgang Glenz (Munich, Vienna: Hanser, 1985), pp. 39–41. Ernst Trommsdorff, *Dr. Otto Röhm*, Chemiker und Unternehmer (Düsseldorf, Vienna: Econ, 1984), pp. 187–236; Jeffrey L. Meikle, *American Plastic*, A Cultural History (New Brunswick/N. J.: Rutgers University Press, 1995), pp. 85–89; Susan Mossman, "Perspectives on the history and technology of plastics," in *Early Plastics*, Perspectives, 1850–1950, ed. Susan Mossman (London: Leicester University Press, 1997), p. 59; Sheldon Hochheiser, *Rohm and Haas*, History of a Chemical Company (Philadelphia/Pa.: University of Pennsylvania Press, 1986).

2 See Ernst Trommsdorff, *Dr. Otto Röhm*, Chemiker und Unternehmer (Düsseldorf, Vienna: Econ, 1984), pp. 253–254; Jeffrey L. Meikle, *American Plastic*, A Cultural History (New Brunswick/N. J.: Rutgers University Press, 1995), pp. 88; 157–158; Susan Mossman, "Perspectives on the history and technology of plastics," in *Early Plastics*, Perspectives, 1850–1950, ed. Susan Mossman (London: Leicester University Press, 1997), p. 60.

3 See Günter Lattermann, "Die Bayreuther Parsifaltaube von 1935/36," to be published in *e-plastory*, Zeitschrift für Kunststoffgeschichte.

4 See Ernst Trommsdorff, *Dr. Otto Röhm*, Chemiker und Unternehmer (Düsseldorf, Vienna: Econ, 1984), p. 239; Rainer Klitzsch, "The sound of music with *Plexiglas*," *Röhm Spektrum* 39 (1991): 34–41.

5 Wind instruments made of *Plexiglas* were particularly in demand among German military bands in the Africa campaign, because they expand less at high temperatures than wooden instruments, and cannot warp in high humidity. Added to this was the Nazi régime's autonomy drive to avoid importing noble timber from abroad. See Rainer Klitzsch's transcripts based on oral information from Joachim Spranger (Erlbach) and Wilhelm Mönnig (Markneukirchen) in the archives of Röhm GmbH, Darmstadt, 6.2.20, folder "Blasinstrumente".

6 Patrick O'Higgins, *Madame*, An Intimate Biography of Helena Rubinstein (New York: Viking Press, 1971), p. 59.

7 See Jean O. Reinecke, "Design dates your product," *Modern Plastics* 15 (1937), Issue 2: 122–123; Kai Buchholz, "Imitationen – Mehr Schein als Sein?" in *Im Designerpark*, ed. Kai Buchholz, Klaus Wolbert (Darmstadt: Häusser, 2004), pp. 82–87.

8 See e. g. Henry van de Velde, "Prinzipielle Erklärungen," in *Kunstgewerbliche Laienpredigten* (Leipzig: Seemann, 1902), pp. 165–166: "As soon as a new material is invented or discovered, the first question is which existing material it might best imitate. Stucco, cement, celluloid and linoleum are possibilities. If, on the contrary, one were to ask oneself whether the new material might not replace the old, and which new, unsatisfied needs it would meet, this question would surely appear justified, and the result would thus pursue its destiny in the ordinary way, enriching the generally produced forms by as yet non-existent ones. ... The material selected for imitation is not ugly in itself, and each material bears the traces of a special beauty that may forever remain concealed from us." (courtesy translation from German)

9 John Gloag, *Plastics and Industrial Design*, (London: Allen & Unwin, 1945), p. 50.

10 See Peter Sulzer, *Jean Prouvé*, Œuvre complète, Vol. 2 (Basel, Boston, Berlin: Birkhäuser, 2000), pp. 164–165; 339; Yvonne Brunhammer, "Jean Prouvé et l'Union des Artistes Modernes," in *Jean Prouvé 'constructeur'* (Paris: Centre Georges Pompidou, 1990), pp. 111–117. Prouvé himself said the following on furniture construction: "Constructing an item of furniture is a serious business, all the more so if one hopes to distribute it on a large scale. Furniture is subjected to very rough treatment. We expect it to stand up under heavy stress. We make all sorts of demands upon it. The problems set by furniture are just as complex as those concerned with large structures. I used to think of furniture as being on a par with the seating of heavy-duty machinery. I therefore took the same care over construction and applied the same tensile standards to the materials, indeed using the very same materials." (Jean Prouvé, "There is no difference between the construction of an item of furniture and that of a house," in *Jean Prouvé*, Architecture, industrie (Paris: Wient, 1985), p. 142.)

11 See Andrea DiNoto, *Art Plastic*, Designed for Living (New York: Abbeville Press, 1984), pp. 174–175; 180–181.

10 Vgl. Peter Sulzer: Jean Prouvé. Œuvre complète. Bd. 2. Basel, Boston, Berlin 2000. S. 164/165; 339; Yvonne Brunhammer: Jean Prouvé et l'Union des Artistes Modernes. In: Jean Prouvé ›constructeur‹. Kat. Centre Georges Pompidou, Paris 1990. S. 111–117. Zur Frage des Möbelbaus äußert sich Prouvé selbst wie folgt: „Die Konstruktion eines Möbelstücks ist eine wichtige, sogar sehr wichtige Sache, vor allem wenn es darum geht, Typen zu schaffen, die in großer Serie hergestellt werden sollen. Ein Möbelstück ist einer starken Beanspruchung ausgesetzt und muß daher eine entsprechende Widerstandskraft aufweisen. Dabei gibt es ebenso komplexe Probleme zu lösen wie bei großen Baukonstruktionen. Für mich sind die Möbel vergleichbar mit stark beanspruchten Maschinenrahmen, und das führte mich dazu, sie mit der gleichen Sorgfalt, also nach den gleichen Statikgesetzen, ja sogar aus den gleichen Materialien zu gestalten." (Jean Prouvé: Zwischen der Konstruktion eines Möbelstückes und eines Hauses besteht kein prinzipieller Unterschied. In: Jean Prouvé. Architecture, industrie. Paris 1985. S. 142.)

11 Vgl. Andrea DiNoto: Art Plastic. Designed for Living. New York 1984. S. 174/175; 180/181.

12 Vgl. Renate Ulmer: Zwischen Art Déco und Stromlinien-Design. Der Durchbruch des Kunststoffs in den zwanziger und dreißiger Jahren. In: Josef Straßer und Renate Ulmer: Plastics + Design. Stuttgart 1997. S. 30/31.

13 Vgl. Norman Bel Geddes: Horizons in Industrial Design. New York 1977. S. 3–5.

14 Vgl. Renate Ulmer: Zwischen Art Déco und Stromlinien-Design. Der Durchbruch des Kunststoffs in den zwanziger und dreißiger Jahren. In: Josef Straßer und Renate Ulmer: Plastics + Design. Stuttgart 1997. S. 31/32; Jeffrey L. Meikle: Plastics in the American machine age. 1920–1950. In: The Plastics Age. From Modernity to Post-Modernity. Hg. P. Sparke. London 1990. S. 41–53; Sylvia Katz: Classic Plastics. From Bakelite to High-Tech. London 1984. S. 11/12; Rudolf Sonntag: Entwicklung der Spritzgießtechnik. In: Kunststoffe – ein Werkstoff macht Karriere. Hg. W. Glenz. München, Wien 1985. S. 155–172.

12 See Renate Ulmer, "Between art deco and streamlined design, The breakthrough of plastic in the twenties and thirties," in Josef Straßer, Renate Ulmer, *Plastics + Design* (Stuttgart: Arnoldsche Art Publishers, 1997), pp. 30–31.

13 See Norman Bel Geddes, *Horizons in Industrial Design* (New York: Dover, 1977), pp. 3–5.

14 See Renate Ulmer, "Between art deco and streamlined design, The breakthrough of plastic in the twenties and thirties," in Josef Straßer, Renate Ulmer, *Plastics + Design* (Stuttgart: Arnoldsche Art Publishers, 1997), pp. 31–32; Jeffrey L. Meikle, "Plastics in the American machine age, 1920–1950," in *The Plastics Age*, From Modernity to Post-Modernity, ed. Penny Sparke (London: Victoria & Albert Museum, 1990), pp. 41–53; Sylvia Katz, *Classic Plastics*, From Bakelite to High-Tech (London: Thames and Hudson, 1984), pp. 11–12; Rudolf Sonntag, "Entwicklung der Spritzgießtechnik," in *Kunststoffe – ein Werkstoff macht Karriere*, ed. Wolfgang Glenz (Munich, Vienna: Hanser, 1985), pp. 155–172.

Wie wird Acrylglas hergestellt?

Die Erzeugung von Acrylglas erfolgt in einer langen Reihe komplexer chemischer Prozesse. Ausgangsstoff der letzten Umsetzung, der →Polymerisation, ist das →monomere Methylmethacrylat (MMA), eine wasserklare, fruchtartig riechende Flüssigkeit, die unter anderem aus dem Erdölderivat Aceton hergestellt wird. Unter der Einwirkung von Licht und Wärme schließen sich die →Moleküle des Methylmethacrylats bei Zugabe geeigneter →Initiatoren zu langen Ketten zusammen. So entsteht ein fester, farblos klarer Stoff: das Polymethylmethacrylat (PMMA) oder Acrylglas, das auch durchscheinend oder gedeckt eingefärbt werden kann. Es wird in Form von Halbzeug (Platten, Rohre, Stäbe) angeboten oder als →Formmasse, die sich aufschmelzen und in die gewünschte Endform bringen lässt. Die Herstellung der Halbzeuge erfolgt entweder im Kammerguss-Verfahren, bei dem das MMA zwischen zwei Glas- oder Metallplatten zur Reaktion gebracht wird, im kontinuierlichen Gießverfahren zwischen zwei Metallbändern oder durch Strangpressen (Extrudieren) des zuvor synthetisierten Materials. Die Gestalt, die das PMMA nach dem Austritt aus dem Extruder annimmt, richtet sich nach der jeweilig verwendeten Düsengeometrie. Zur Erzeugung der Formmassen wird heute meist nicht mehr die klassische →Perlpolymerisation durchgeführt, sondern ein rationelleres Verfahren. In einem kontinuierlich betriebenen Rührkessel reagiert dabei das Monomere zusammen mit den notwendigen Initiatoren und Kettenreglern unter hoher Temperatur rasch zu einer Lösung des Polymeren im Monomeren. Von unverbrauchten Monomeren befreit, wird der so produzierte Kunststoff am Ende granuliert.

How Is Acrylic Manufactured?

Acrylic is manufactured in a long series of complex chemical processes. The starting material for the last conversion process, →polymerization, is →monomeric methyl methacrylate (MMA), a clear liquid with a fruity odor that is obtained from the petroleum derivative acetone, among other substances. Under the influence of light and heat, the methyl methacrylate →molecules join up to form long chains upon addition of suitable →initiators. The result is a solid, clear-transparent material, polymethyl methacrylate (PMMA, acrylic), which can also be provided in translucent or opaque colors. It is supplied in the form of sheet material, tubes and rods, or as →molding compound that is melted and formed into the desired end product. Sheet material is manufactured either by the cell-cast method, in which the MMA is reacted between two sheets of glass or metal, by continuous casting between two metal belts or by extruding the previously synthesized material. The shape PMMA assumes when it exits the extruder depends on the die geometry. Molding compound is nowadays no longer manufactured by the classical →bead polymerization method, but by a more economical process. In this, the monomer in a continuous stirred tank reacts quickly at high temperature with the required initiators and chain modifiers to provide a polymer-in-monomer solution. After the residual monomer has been removed, the plastic is granulated.

Cat. 2
Parsifaltaube, 1936
"Parsifal" dove, 1936

Cat. 13, 14, 26
Broschen, Deutschland/Frankreich, Ende 30er Jahre
Brooches, Germany/France, late 1930s

Cat. 38, 39
Beauty-Bags, USA, 40er Jahre
Beauty bags, USA, 1940s

Cat. 23
Schreibset, Frankreich, Ende 30er Jahre
Writing set, France, late 1930s

Cat. 28
Schatulle, Ende 30er Jahre
Casket, late 1930s

Cat. 10
Schale mit Standfuß, Deutschland, Ende 30er Jahre
Bowl with stand, Germany, late 1930s

Cat. 5
Gartensessel, 1937
Garden chair, 1937
Entwurf | Design: Jacques André, Jean Prouvé

Cat. 7
Radiogerät mit zwei Lautsprechern, Großbritannien, um 1938
Radio set with two speakers, United Kingdom, ca. 1938

Cat. 34
Abendschuh, 1941
Evening shoe, 1941
Entwurf | Design: Frankfurter Modeamt

Cat. 9
Briefständer, Frankreich, um 1938
Letter stand, France, ca. 1938

Cat. 31
Klapp-Zigarettendose, Frankreich, um 1940
4-compartment cigarette box with hinged lid, France, ca. 1940

Klar und sauber
Durchblick im Wirtschaftswunder

All Clear Ahead
for the German Economic Miracle

Als der Acrylglasbedarf für die Produktion von Kampfflugzeugen bei Kriegsende abrupt versiegt, begeben sich die Hersteller des Materials auf die Suche nach neuen Märkten. Gleichzeitig erproben findige Tüftler verschiedene Wege, auf denen sich überschüssiges PMMA aus dem Flugzeugbau weiterverwenden lässt. So werden Acrylglasreste in Deutschland unter anderem zu Armreifen und Broschen verarbeitet. In den USA entwickelt ein ehemaliger Unteroffizier der Luftstreitkräfte Tische, Pflanzschalen und Goldfischgläser aus nicht mehr benötigten PMMA-Nasen des B-29-Bombers, die von der Firma Tropicmode Furniture in Hollywood vertrieben werden.[1]

Auch der legendäre Messerschmitt Kabinenroller mit seitlich hochklappbarer Acrylglashaube verdankt seine Existenz dem Experimentiergeist der Nachkriegszeit. Ab 1948 bietet der Flugzeugingenieur Fritz Fend einen vornehmlich für Beinamputierte gedachten dreirädrigen Einsitzer an. Auf Drängen Willy Messerschmitts erweitert er seinen „Fend Flitzer" 1952 um einen zusätzlichen Sitzplatz, modifiziert die Karosserie und verschließt das Fahrzeug mit der besagten cockpitartigen Kunststoffhaube, die auf Grund ihres geringen Gewichts und ihrer Witterungsbeständigkeit ideal geeignet ist. Bereits im

Tankstelle mit Regendach aus klarem *Plexiglas*, um 1958
Gas station with canopy made of clear-transparent *Plexiglas*, ca. 1958

When the demand for acrylic in fighter planes dried up at the end of the war, the manufacturers began to look for new markets for the material. At the same time, resourceful inventors explored various ways of using PMMA left over from aircraft construction. In Germany, acrylic scrap was made into bracelets and brooches. In the USA, a former airforce sergeant developed tables, planters and goldfish bowls from the leftover PMMA nose cones of the B-29 bomber that were marketed by Tropicmode Furniture in Hollywood.[1]

The legendary Messerschmitt microcar with its acrylic canopy that folded up on one side also had the pioneering spirit of the postwar years to thank for its invention. In 1948, aircraft engineer Fritz Fend came up with a one-seater tricycle intended mainly for leg amputees. At the prompting of Willy Messerschmitt, he added another seat to the 1952 model of his "Fend Flitzer," modified the chassis and closed the vehicle with the plastic cockpit, whose low weight and excellent weather resistance made it ideal for that purpose. In spring 1953, the aerodynamic dwarf named "Messerschmitt Kabinenroller KR 175" went into mass production at the Messerschmitt factory in Regensburg. It was followed two years later by the KR 200, an improved model produced up to 1964. Thirty thousand of these were sold.[2]

In addition to automotive construction[3], where PMMA also gained the taillight market, the material became widely used in various fields of architecture dating from the 1950s. Acrylic became the architects' darling

Frühjahr 1953 geht der windschnittige Zwerg unter dem Namen „Messerschmitt Kabinenroller KR 175" im Regensburger Messerschmitt-Werk in die Serienproduktion. Zwei Jahre später folgt mit dem KR 200 ein verbessertes Modell, das bis 1964 produziert und insgesamt etwa 30 000 mal verkauft wird.[2]

Neben dem Automobilbau[3], wo PMMA auch den Heckleuchtenmarkt für sich gewinnt, findet das Material ab den 50er Jahren vor allem in verschiedenen Sparten der Architektur weite Verbreitung. Insbesondere für die Herstellung von Balkonbrüstungen, Lichtkuppeln und transluzenten Dächern wird Acrylglas gerne eingesetzt, was in Zeiten des Wiederaufbaus eine starke Nachfrage nach dem durchsichtigen Kunststoff bewirkt.[4] Unter den veränderten Lebensbedingungen der Nachkriegszeit

for manufacturing balcony guards, light domes and translucent roofs, creating a strong demand for the transparent plastic during the era of German reconstruction.[4] With the change in living conditions following the war, new attributes of the material suddenly came to the fore and determined its design. Amid the general feeling of loss and disorientation, it was no longer admired for its magic and mystery, but appreciated for its clear, clean look instead.

Fritz Fend stellt den FMR Tg 500 in England vor, 1958
Fritz Fend presenting the FMR Tg 500 in England, 1958

Miniatur-Telefonzellen mit Schallschutz aus *Plexiglas*, um 1957
Miniature phone booths with *Plexiglas* sound insulation, ca. 1957

treten plötzlich neue Attribute des Materials hervor, die auch das Design bestimmen. Angesichts allgemeiner Orientierungslosigkeit weidet man sich nicht mehr an seinem geheimnisvollen Zauber, sondern schätzt jetzt vor allem seine klare, saubere Ausstrahlung.

Mit dem Wirtschaftswunder – der zunehmenden Kaufkraft der späten 50er Jahre – entwickelt sich auch die Werbebranche zu einem florierenden Geschäftszweig.[5] Hier übernimmt Acrylglas als Material für illuminierte Außenwerbungen die klare Führungsrolle – bis heute ein Produktbereich mit hohem PMMA-Verbrauch.[6] Wie der Designhistoriker Jeffrey L. Meikle feststellt, werden die ersten Leuchtreklamen aus Acrylglas an Tankstellen aufgebaut, von wo aus sie nach und nach den „Neon-Dschungel der amerikanischen Nächte"[7] erobern.

Die Verkleidung von Jukeboxen erschließt den amerikanischen Werkstoff-Lieferanten zeitgleich ein zusätzliches Aufgabenfeld. Die hohe Transparenz des Acrylglases wird hier wirkungsvoll eingesetzt, um das automatische Abspielen von Schallplatten wie auf einer Bühne zu inszenieren, wobei hinterleuchtete Frontglasteile aus farbigem PMMA den Musikautomaten ein lebendiges Äußeres verleihen. Der amerikanische

With the advent of the *Wirtschaftswunder*, the German economic miracle attended by increased spending power in the late 1950s, advertising became a flourishing branch of industry.[5] Acrylic quickly took center stage as a material for illuminated signs, which still demand large volumes of PMMA today.[6] As design historian Jeffrey L. Meikle notes, the first illuminated signs made of acrylic were put up at gas stations. Bit by bit, they went on from there to conquer the "neon jungle of the American night"[7].

An additional field of activity for US suppliers of acrylic was jukebox housings. In these, the high transparency of acrylic was effectively used to present the automatic record play for all to see. Lit from behind, the front glazing made of colored PMMA added further pizzazz to the music boxes. American manufacturer *Wurlitzer* started experimenting with the acrylic *Lucite* in 1937 and inspired his designer-in-chief Paul Fuller, originally trained in furniture design, to create sophisticated decorative effects.[8] Jukebox expert Werner Reiß writes of Fuller's classic Model 1100: "With his last draft for Wurlitzer in 1948, Paul Fuller anticipated the techno design of the 1950s. The curved glass hood over the mechanical innards recalls the nose cone of a B-17 bomber, and the chrome

Turm Palast

...HTS IM GRÜNEN KAKADU

Hersteller *Wurlitzer* beginnt bereits 1937, mit dem Acrylglas *Lucite* zu experimentieren, was den Chefdesigner, den gelernten Möbelentwerfer Paul Fuller, dazu inspiriert, raffinierte dekorative Effekte zu kreieren.[8] Der Musikautomaten-Experte Werner Reiß schreibt über Fullers klassisches Modell 1100: „Mit seinem letzten Entwurf für Wurlitzer nahm Paul Fuller bereits 1948 das Techno-Design der 1950er Jahre vorweg. So erinnert die gewölbte Glashaube über der Mechanik an die Rumpfnase eines B-17-Bombers und die Chromspangen an der unteren Lautsprecherverkleidung zitieren die Kühlergrillgestaltung des Buick ›Eight‹ von 1947."[9]

Qualitätvolle Designobjekte aus PMMA entstehen während der 50er Jahre hauptsächlich im Bereich der Innendekoration. So entwerfen die ehemaligen Bauhaus-

Kinowerbung aus *Plexiglas*, um 1958 (S. 48/49)
Movie theater sign made of *Plexiglas*, ca. 1958 (pp. 48–49)

Hamburger Hafenboot mit Fenstern aus *Plexiglas*, um 1961
Boat in Hamburg harbor with *Plexiglas* windows, ca. 1961

Möbel aus *Plexiglas*, um 1960
Furniture made of *Plexiglas*, ca. 1960

bars on the lower speaker panels refer to the radiator grille of the 1947 Buick 'Eight'."[9]

Most of the quality design objects made of PMMA in the 1950s stem from interior design. During this period, former Bauhaus students Wolfgang Tümpel and Hanns Hoffmann-Lederer designed a large number of table, wall and hanging lamps made from PLEXIGLAS®. Although plastics had played

schüler Wolfgang Tümpel und Hanns Hoffmann-Lederer in dieser Zeit zahlreiche Tisch-, Wand- und Hängeleuchten aus PLEXIGLAS®. Trotz der untergeordneten Rolle, die Kunststoffe im Bauhaus spielten, hatte László Moholy-Nagy dort bereits Acrylglas für seine konstruktivistischen Skulpturen verwendet.[10]

Wolfgang Tümpel, der ab 1951 die Metallklasse an der Hamburger Landeskunstschule leitet, hatte sich während des Dritten Reiches in die innere Emigration zurückgezogen und auf die Herstellung kunsthandwerklicher Einzelstücke verlegt. Nach dem Krieg widmet er sich verstärkt dem Industriedesign, wodurch er auch mit dem Werkstoff Acrylglas in Berührung kommt. Die von ihm entworfenen Leuchten aus klarem PMMA für Verarbeiter wie Carl W. Kopperschmidt, Carl Prediger und die Glaswerke Haller stehen größtenteils in einer handwerklich

a subordinate role in Bauhaus, László Moholy-Nagy had made early use of acrylic for his Constructivist sculptures.[10]

Wolfgang Tümpel, who taught the metal class at Hamburg's Landeskunstschule from 1951, had followed other artists into 'inner emigration' during the Third Reich and turned to crafting individual items. After the war, he increasingly focused on industrial design and also came into contact with acrylic material. The lighting he created in clear PMMA for fabricators like Carl W. Kopperschmidt, Carl Prediger and Glaswerke Haller largely follows the tradition of craftsmanlike design. This tendency is attested by a set of silver salad servers with acrylic handles designed by Tümpel in the 1950s, whose sumptuous elegance recalls the PMMA objects of the late 1930s.[11]

As a professor at Darmstadt's Werkkunstschule, Hanns Hoffmann-Lederer maintained direct contacts with Röhm &

ausgerichteten Formgebungstradition. Diese Tendenz belegt auch ein silbernes Salatbesteck mit Acrylglasgriffen Tümpels aus den 50er Jahren, das in seiner feierlichen Gediegenheit an PMMA-Objekte der späten 30er Jahre erinnert.[11]

Als Professor an der Werkkunstschule Darmstadt steht Hanns Hoffmann-Lederer in direktem Kontakt mit der Röhm & Haas GmbH. Dabei lernt er den verarbeitungsfreundlichen Kunststoff kennen und verwandelt sich in einen begeisterten Bewunderer von *Plexiglas*. Dies verdankt sich nicht zuletzt den Erfahrungen, die er mit dem Werkstoff in seinem Grundlagenunterricht sammelt. Im Sinne seines Lehrers Johannes Itten vermittelt Hoffmann-Lederer den angehenden Gestaltern ästhetisches Empfinden und künstlerische Fertigkeiten unter anderem mittels spielerischer Materialerkundungen, für die sich PMMA vorzüglich eignet. Wie aus den Nachforschungen der Volkskundlerin Anne Feuchter-Schawelka hervorgeht, nimmt der freie, experimentelle Umgang mit dem Kunststoff auch bei seiner Arbeit an den meist aus milchigweißem Acrylglas gefertigten Leuchten eine wichtige Rolle ein: "In seinen eigenen Entwürfen mit ›Plexiglas‹ ging Hoffmann-Lederer von der Tafel aus und wickelte diese sich sozusagen um die Hand. Er rollte das Plexiglas an den Enden ein, drückte es und bog Spiralen, Tüten, Schlaufen, Wellen und anderes daraus und versah seine Ergebnisse mit Glühbirnen."[12] Neben den von Heinz Hecht, später von der Endemann GmbH produzierten Leuchten entwirft Hoffmann-Lederer Brieföffner, Lupen, Schmuck und Möbelstücke aus Acrylglas. 1957 erhält er

Acrylglas-Modell einer schwangeren Frau, Museum of Science and Industry Chicago, um 1947
Acrylic model of a pregnant woman, Chicago Museum of Science and Industry, ca. 1947

Haas GmbH. Through these contacts, he grew acquainted with the easily shaped plastic and became an ardent admirer of *Plexiglas*. His love affair with the material was based on the experience gained in his basic design courses. Following the example of his teacher Johannes Itten, Hoffmann-Lederer schooled the aesthetic sensibility and artistic skills of his design students by playfully exploring materials. PMMA was the perfect candidate for such endeavors. As evidenced by the research of folklorist Anne Feuchter-Schawelka, the free and experimental approach to the plastic also played a predominant role in his work on

„Das Material hat sich mir, ich kann es nicht anders ausdrücken, in die Hand gegeben, hat mir seine Möglichkeiten anvertraut und so die Gestalt meiner künstlerischen Vorstellung angenommen."

Hanns Hoffmann-Lederer

lamps, most of which were made from milky white acrylic: "In his own designs with 'Plexiglas,' Hoffmann-Lederer started with sheet material and wrapped it around his hand. He rolled the material up from the ends, pressed it and bent it into spirals, pouches, loops, waves and other shapes, and crowned the results with light bulbs."[12] As well as the lighting produced by Heinz Hecht and later by Endemann GmbH, Hoffmann-Lederer designed letter openers, magnifying glasses, jewelry and furniture made from acrylic. At the XI Triennale in Milan 1957, he even received a gold medal for his *Plexiglas* magnifying glass No. 101.

Like Hoffmann-Lederer's lamps, the acrylic designs of Estelle and Erwine Laverne speak the language of soft, organic forms. An excellent example is their armchair "Lily" from the late 1950s. Apart from an inconspicuous upholstered seat, this piece of furniture is made entirely of transparent acrylic. Its air of weightlessness prefigures the carefree abandon of the pop art era, while its magnificent floral shape appears to flow straight on from where Streamline left off.

During the same period, designers at the Ulm School of Design adhere to a strictly rational functionalism that consciously opposes the decorative dynamics of mainstream organic design. The SK 4, a radio and record player set

auf der XI. Triennale in Mailand für seine *Plexiglas* Lupe Nr. 101 sogar eine Goldmedaille.

Vergleichbar den Leuchten Hoffmann-Lederers, sind auch die Entwürfe für Acrylglas von Estelle und Erwine Laverne einer organisch-weichen Formensprache verpflichtet. Ein ausgezeichnetes Beispiel dafür ist der aus den späten 50er Jahren stammende Sessel „Lily". Abgesehen von einem unauffälligen Sitzpolster besteht das gesamte Möbelstück aus transparentem Acrylglas. Seine schwebende Leichtigkeit weist bereits auf die Freizügigkeit der Pop-Ära voraus, während seine prunkvolle lilienförmige Gestalt an die Ideale des Streamline anknüpft.

In bewusster Opposition zur dekorativen Dynamik des weit verbreiteten organischen Designs verschreiben sich die Entwerfer der Hochschule für Gestaltung Ulm zeitgleich einem streng rationalen Funktionalismus. Der von Hans Gugelot und Dieter Rams 1956 für die Braun AG entworfene Phonosuper SK 4 läutet eine neue Epoche im Elektrogerätedesign ein. Seine unauffällig-zurückhaltende Formgebung sowie die klare, übersichtliche Anordnung seiner Bedienungselemente stellen den funktionalen Charakter von Gebrauchsgegenständen ins Zentrum einer neuen Produkt-Ethik. Eigentlich passt es dazu nicht so recht, dass das Gerät, mittlerweile zum Designklassiker avanciert, unter Liebhabern bis heute den Spitznamen „Schneewittchensarg" trägt, übrigens dieselbe Bezeichnung, die auch dem Messerschmitt Kabinenroller beigelegt wird. Im Falle des SK 4 verdankt sich der Ausdruck der transparenten Acrylglas-Abdeckung, die den Blick auf den Plattenteller frei gibt. Ursprünglich planen die Entwerfer, die Abdeckung aus Metall fertigen zu lassen, doch wegen des vorteilhaften Resonanzverhaltens von PMMA entscheiden sie sich am Ende für den durchsichtigen Kunststoff.[13]

designed in 1956 by Hans Gugelot and Dieter Rams for Braun AG rings in a new era of electrical appliance design. Both its restrained, unobtrusive shape and the clear arrangement of its controls place the functional character of everyday commodities at the center of a novel product ethic. So it is something of a contradiction that the appliance, having gained the status of a design classic, is still known today among aficionados by the affectionate nickname "Snow White's coffin" (an epithet it shares, incidentally, with the Messerschmitt microcar). In the SK 4, this refers to the transparent acrylic cover that offers a clear view of the turntable. The designers had originally planned to have the cover made of metal, but in the end they opted for the transparent plastic because of the better resonance properties of PMMA.[13]

"The material nestled into my hand – there's no other way of putting it. It entrusted me with its possibilities and took on the shape of my artistic imaginings."

Hanns Hoffmann-Lederer

Raumteiler aus klarem, gewellten *Plexiglas*, 1953
Partition made of clear corrugated *Plexiglas*, 1953

Anmerkungen

1 Vgl. Anonymus: War-plane blisters in peace-time use. In: Modern Plastics. 26 (1948), Heft 3. S. 89.

2 Vgl. Jens Kron: Messerschmitt Kabinenroller. Die flotten Flitzer der 50er Jahre. Regenstauf 2006.

3 Zur Verwendung von PMMA im Automobilbau vgl. u. a. Anonymus: *Plexiglas* on the highways. Automotive industry uses acrylic sheets and molding powders in wide variety of applications. In: The Rohm & Haas Reporter. 7 (1949), Heft 2. S. 10–15; Anonymus: Mehr Sicherheit und Komfort auch für Ihr Auto. In: Röhm Spektrum. 10 (1973). S. 28/29; Rainer Klitzsch: Auto und Fortschritt – bei uns ein Thema, schon seit 60 Jahren. In: Röhm Spektrum. 36 (1988). S. 48–51; Anton Weber: Kunststoffe im Auto. In: Phantastisch plastisch. Was nur Kunststoffe können. Hg. Kunststoff-Museums-Verein Düsseldorf. München 1995. S. 65–73.

4 Vgl. z. B. Plexiglas im Bild. 1957, Heft 1. S. 4/5; Plexiglas im Bild. 1958, Heft 3. S. 2–7; Plexiglas im Bild. 1959, Heft 1. S. 7; Plexiglas im Bild. 1959, Heft 2. S. 8/9; Anonymus: Der Architekt und die Lichtkuppeln. In: Plexiglas im Bild. 15 (1963). S. 10–15.

5 Vgl. Heinz-Gerhard Haupt: Konsum. In: Im Designerpark. Hg. K. Buchholz, K. Wolbert. Darmstadt 2004. S. 956–961.

6 Vgl. z. B. Plexiglas im Bild. 1957, Heft 3. S. 13; Plexiglas im Bild. 1958, Heft 3. S. 16/17; Plexiglas im Bild. 1960, Heft 1. S. 14–17; Anonymus: The sign of a refreshing drink. In this and many other countries, Coca-Cola is practically ›within an arm's reach of desire‹. Its presence often announced by a sign made of *Plexiglas*. In: The Rohm & Haas Reporter. 11 (1953), Heft 5. S. 16–21; 29.

7 Übersetzt nach Jeffrey L. Meikle: American Plastic. A Cultural History. New Brunswick/N. J. 1995. S. 186.

8 Vgl. John Krivine: Juke Box Saturday Night. London 1977. S. 148–152.

9 Werner Reiß: Johann Strauß meets Elvis. Musikautomaten aus zwei Jahrhunderten. Stuttgart 2003. S. 166.

10 Vgl. Ernst Trommsdorff: *Plexigum* und *Plexiglas*. In: Deutsches Jahrbuch für die Industrie der plastischen Massen. 3 (1937/38). S. 123–129; Anca Arghir: Transparenz als Werkstoff. Acrylglas in der Kunst. Köln 1988. S. 42–47.

11 Vgl. Gabriele Koller: Wolfgang Tümpel als Formgestalter für die Industrie. In: Wolfgang Tümpel 1903–1978. Ein Bauhauskünstler aus Bielefeld. Hg. H. Wiewelhove. Kat. Museum Huelsmann. Bielefeld 2003. S. 37–43. Zu Tümpels Leuchten aus *Plexiglas* vgl. Plexiglas in der Lichttechnik. Darmstadt 1956. S. 34–36; Plexiglas Lichttechnik. Darmstadt 1957. S. 31–37; Plexiglas im Bild. 1958, Heft 3. S. 9.

12 Anne Feuchter-Schawelka: Die organische und asymmetrische Form. Hoffmann-Lederers Design in den 50er Jahren. In: Hanns Hoffmann-Lederer. Bauhäusler, Grafiker, Maler, Formgestalter, Plastiker. Hg. A. Hoormann. Weimar 2001. S. 49. Die gegen rationalistische Entwurfsformen gerichtete Verfahrensweise Hoffmann-Lederers charakterisiert dieser selbst wie folgt: „Die freien Formen liegen einfach in der Luft unserer Zeit. Die Entwicklung drängt von der reinen Funktion zur lebendigen Gestalt." (Nachlass Hoffmann-Lederer, Akte 3/9 – 5).

13 Vgl. Inez Franksen, Dieter Rams und Dieter Skerutsch: Vier Entwicklungen. In: Design: Dieter Rams. Hg. F. Burkhardt, I. Franksen. Berlin 1980. S. 92/93; Dieter Rams: Erinnerungen an die ersten Jahre bei Braun. In: Dieter Rams, Designer. Die leise Ordnung der Dinge. Hg. Industrie Forum Design Hannover. Göttingen 1990. S. 202–207.

Notes

1 See anonymous, "War-plane blisters in peace-time use," *Modern Plastics* 26 (1948), Issue 3: 89.

2 See Jens Kron, *Messerschmitt Kabinenroller*, Die flotten Flitzer der 50er Jahre (Regenstauf: Battenberg, 2006).

3 On the use of PMMA in automotive construction, see anonymous, "*Plexiglas* on the highways, Automotive industry uses acrylic sheets and molding powders in wide variety of applications," *The Rohm & Haas Reporter* 7 (1949), Issue 2: 10–15; anonymous, "More safety and comfort for your car," *Röhm Spektrum* 10 (1973): 28–29; Rainer Klitzsch, "Automotive progress – a subject we have been studying for the past 60 years," *Röhm Spektrum* 36 (1988): 48–51; Anton Weber, "Kunststoffe im Auto," in *Phantastisch plastisch*, Was nur Kunststoffe können, ed. Kunststoff-Museums-Verein (Düsseldorf, Munich: Verlag für Messepublikationen, 1995), pp. 65–73.

4 See *Plexiglas im Bild* 1957, Issue 1: 4–5; *Plexiglas im Bild* 1958, Issue 3: 2–7; *Plexiglas im Bild* 1959, Issue 1: 7; *Plexiglas im Bild* 1959, Issue 2: 8–9; anonymous, "Der Architekt und die Lichtkuppeln," *Plexiglas im Bild* 15 (1963): 10–15.

5 See Heinz-Gerhard Haupt, "Konsum," in *Im Designerpark*, ed. Kai Buchholz, Klaus Wolbert (Darmstadt: Häusser, 2004), pp. 956–961.

6 See *Plexiglas im Bild* 1957, Issue 3: 13; *Plexiglas im Bild* 1958, Issue 3: 16–17; *Plexiglas im Bild* 1960, Issue 1: 14–17; anonymous, "The sign of a refreshing drink, In this and many other countries, Coca-Cola is practically 'within an arm's reach of desire,' its presence often announced by a sign made of *Plexiglas*," *The Rohm & Haas Reporter* 11 (1953), Issue 5: 16–21; 29.

7 Jeffrey L. Meikle, *American Plastic*, A Cultural History (New Brunswick/N. J.: University of Pennsylvania Press, 1995), p. 186.

8 See John Krivine, *Juke Box Saturday Night* (London: New English Library, 1977), pp. 148–152.

9 Werner Reiß, *Johann Strauß meets Elvis*, Musikautomaten aus zwei Jahrhunderten (Stuttgart: Arnoldsche Art Publishers, 2003), p. 166.

10 See Ernst Trommsdorff, "*Plexigum* und *Plexiglas*," *Deutsches Jahrbuch für die Industrie der plastischen Massen* 3 (1937/38): 123–129; Anca Arghir, *Transparenz als Werkstoff*, Acrylglas in der Kunst (Cologne: Wienand, 1988), pp. 42–47.

11 See Gabriele Koller, "Wolfgang Tümpel als Formgestalter für die Industrie," in *Wolfgang Tümpel 1903–1978*, Ein Bauhauskünstler aus Bielefeld, ed. Hildegard Wiewelhove (Bielefeld: Museum Huelsmann, 2003), pp. 37–43. On Tümpel's lamps made from *Plexiglas*, see *Plexiglas in der Lichttechnik* (Darmstadt: Röhm & Haas, 1956), pp. 34–36; *Plexiglas Lichttechnik* (Darmstadt: Röhm & Haas, 1957), pp 31–37; *Plexiglas im Bild* 1958, Issue 3: 9.

12 Anne Feuchter-Schawelka, "Die organische und asymmetrische Form, Hoffmann-Lederers Design in den 50er Jahren," in *Hanns Hoffmann-Lederer*, Bauhäusler, Grafiker, Maler, Formgestalter, Plastiker, ed. Anne Hoormann (Weimar: Bauhaus-Universität Weimar – Universitätsverlag, 2001), p. 49. Hoffmann-Lederer himself characterized the countermovement to rationalistic design as follows: "Free forms are all-pervasive in our times. Development is pushing us away from the purely functional to living shapes." (Courtesy translation; from the estate of Hoffmann-Lederer, File 3/9 – 5).

13 See Inez Franksen, Dieter Rams and Dieter Skerutsch, "Vier Entwicklungen," in *Design: Dieter Rams*, ed. François Burkhardt, Inez Franksen (Berlin: Gerhardt, 1980), pp. 92–93; Dieter Rams, "Erinnerungen an die ersten Jahre bei Braun," in *Dieter Rams, Designer*, Die leise Ordnung der Dinge, ed. Industrie Forum Design Hanover (Göttingen: Steidl, 1990), pp. 202–207.

Wie lässt sich Acrylglas verarbeiten?

Aufgeschmolzenes PMMA-Granulat kann durch Strang- oder Spritzgießen in jede beliebige Form gebracht werden. Auch für die Halbzeuge bieten sich vielfältige Verarbeitungsmethoden an: Fertige Acrylglasplatten werden bei Temperaturen zwischen 150° und 175° C elastisch und lassen sich dann mittels Formpressen, Strecken, Biegen und Pressluft umgestalten. Darüber hinaus stehen die – etwa für Holz oder Metall – üblichen spanenden Bearbeitungsverfahren offen. Beim Zerteilen mit Kreis-, Band-, Stich- und Handsägen ist allerdings auf eine materialgerechte Formung der Sägezähne zu achten. Neben dem Schneiden mit scharfen Messern und dem Stanzen kommen auch Ritzbrechen, Wasserstrahl- und Laserschneiden in Frage. Entstehende Schnittkanten können mit der Ziehklinge einfach geglättet und entgratet werden. Zum Bohren von Acrylglas lassen sich Spiralbohrer verwenden, wenn deren Spitzenwinkel vorher auf 60–90° abgeflacht und der Spanwinkel so weit zurückgeschliffen wird, dass der Bohrer nicht schneidet, sondern schabt. Auch das Feilen, Fräsen und Gravieren ist mit gängigen Werkzeugen möglich. Ungewünschte Unebenheiten (Kratzer, Rillen, Sägekanten) können durch gezieltes Fließerhitzen oder durch Schleifen und Polieren beseitigt werden. Beim Polieren dürfen jedoch nur sehr weiche Polierstoffe (Filz, Stoffschwabbelscheibe) und mit Acrylglas verträgliche Polierpasten Verwendung finden. Fügen lassen sich Acrylglasteile mit Spezialklebern sowie durch Schweißen, Nieten, Klemmen, Schrauben und Verwalzen.

How Can Acrylic Be Fabricated?

Molten PMMA pellets can be extruded or injection molded into any desired shape. There are also a range of versatile fabrication methods for sheet material. Acrylic sheets become elastic at temperatures between 150° and 175° C, and can then be formed on presses, by stretching and bending, and with compressed air. The conventional machining methods employed for wood or metal are also suitable. When working with circular saws, bandsaws, jigsaws and handsaws, the sawblades must be correctly shaped for cutting acrylic. The material can also be scored with sharp knives and broken, die-cut, laser-cut or cut with a water jet. The cut edges can be simply smoothed and deburred with a scraper. Acrylic can be drilled using twist drills, provided the point angle has been reduced to 60–90° and the rake angle ground down so that the drill scrapes rather than cuts. Filing, routing and engraving are also possible using conventional tools. Undesired irregularities (scratches, grooves, sawed edges) can be removed by flame polishing or by sanding and polishing. Polishing must be performed with very soft materials (felt, cloth buffing wheel) and using polishing paste that is compatible with acrylic. Acrylic components can be joined using specialty adhesives and by welding, riveting, clamping, screw union and heat lamination.

Cat. 45
Tischleuchte, 1957
Table lamp, 1957
Entwurf | Design: Hanns Hoffmann-Lederer

Cat. 48
Sessel „Lily", um 1958
Armchair "Lily," ca. 1958
Entwurf | Design: Estelle Laverne, Erwine Laverne

Cat. 42
Messerschmitt Kabinenroller KR 200, 1955/56
Messerschmitt microcar KR 200, 1955/56
Entwurf | Design: Fritz Fend

Cat. 49
Deckenleuchte, 50er Jahre
Ceiling lamp, 1950s
Entwurf | Design: Wolfgang Tümpel

Cat. 37
Musikautomat Wurlitzer, Modell 1100, 1948
Wurlitzer jukebox, model 1100, 1948
Entwurf | Design: Paul Fuller

Cat. 44
Phonosuper SK 4 („Schneewittchensarg"), 1956
Phonosuper SK 4 ("Snow White's coffin"), 1956
Entwurf | Design: Hans Gugelot, Dieter Rams, Wilhelm Wagenfeld

Cat. 55
Magnettonbandgerät BG 26, 1963
BG 26 tape recorder, 1963
Entwurf | Design: Ekkehard Bartsch

Cat. 50
Salatbesteck, 50er Jahre
Salad servers, 1950s
Entwurf | Design: Wolfgang Tümpel

Cat. 43
Butterdose, 1955/56
Butter dish, 1955/56
Entwurf | Design: Wilhelm Wagenfeld

Cat. 47
Mechanische Mokkamühle mit abnehmbarer Kurbel, 1957
Mechanical mocca mill with detachable crank, 1957
Werksentwurf | Factory design

Cool Bubbles
Spacedesign für die Blumenkinder

Cool Bubbles
Spacy Design for Flower Children

Woodstock im August 1969: Mehr als 400 000 Fans pilgern zu einem abgelegenen Farmgelände am Kauneonga Lake, um mit coolen Rock- und Folk-Priestern namens Jimi Hendrix, Joan Baez oder Janis Joplin eine antiautoritäre Liturgie des lockeren Lebens zu zelebrieren, ein ekstatisches „Festival for Peace and Music". Britische Popkultur und die Hippiebewegung der amerikanischen West Coast werden hier über Nacht zur Massenbewegung. Es handelt sich um einen Befreiungsschlag, der in den Industrienationen bis heute nachhallt und durch Flower Power, Christopher-Street-Aufstand, Antikriegsdemonstrationen und Studentenrevolte seit längerem vorbereitet ist. In den beliebig formbaren, der individuellen Fantasie keine Grenzen setzenden Kunststoffen erkennt sich die Bewegung wieder, findet die idealen Ausdrucksträger ihrer Visionen und Bedürfnisse.[1] Der Kulturtheoretiker und Werbefachmann Markus Caspers resümiert: „Die Entstehung von Pop als Lebensanschauung verdankt sich der Ablehnung puritanischer Moral, des ihr innewohnenden Arbeitsethos und damit natürlich auch der Ablehnung derer, die für diese Werte stehen: In den sechziger Jahren heißt dieser Gegner ›Establishment‹. Auch im Umgang mit den Dingen, in der alltäglichen Lebensgestaltung, wird der puritanischen Doktrin *Form follows function* (die formalisierte Entsprechung von ›Sex

Woodstock in August 1969: Over 400,000 pilgrims of pop made their way to a remote farm at Kauneonga Lake, to celebrate the anti-authoritarian liturgy of laid-back living. They came together with cool rock and folk priests like Jimi Hendrix, Joan Baez and Janis Joplin to share an ecstatic "Festival for Peace and Music." Overnight, British pop culture and the hippy movement of America's West Coast fused into a mass happening. This blow for liberation still resonates today in industrialized countries and was heralded by Flower Power, the Christopher Street revolt, anti-war demonstrations and student riots. In the freely formable plastics that placed no limits on individual imagination, this movement recognized a kindred spirit and the perfect means of expression for its needs and visions.[1] Culture theoretician and advertising expert Markus Caspers sums up: "The emergence of pop as a philosophy is based on the rejection of puritan morals, the related work ethic and of course all those who represent these values. In the 1960s, they were summed up in just one word: 'the establishment'. In connection with physical objects and everyday life, the puritanical doctrine *Form follows function* (the formalized version of 'Sex is strictly for procreation') was countered by a hedonistic vision of life that questioned a world where usefulness and sense prevailed over sensuality."[2]

The new attitude to life was also reflected in the design of everyday items made from acrylic. The best example is Eero Aarnio's "Bubble Chair" (1968), a swinging hemisphere of transparent PMMA to sit and 'let it all hang out.' It is no coincidence that the futuristic chair with its plump

Vitrinen aus *Plexiglas*, Euro-Shop Düsseldorf, 1970
Showcases made of *Plexiglas*, Euro-Shop Düsseldorf, 1970

nur zur Zeugung von Nachwuchs‹) ein hedonistischer Lebensentwurf entgegengesetzt, der eine auf Nützlichkeit und körperfremde Sinnhaftigkeit gerichtete Welt in Frage stellt."²

Natürlich schlagen sich die neuen Lebensvorstellungen auch im Design von Gebrauchsartikeln aus Acrylglas nieder. Bestes Beispiel ist der „Bubble Chair" (1968) von Eero Aarnio, eine frei schwebende Halbkugel aus transparentem PMMA, in der man lässig baumelnd den Zwängen des Alltags entkommen kann. Nicht zufällig ahmt der futuristische Sessel mit dem satten Sitzpolster aus silberfarbenem Leder die Ästhetik der Mondraketen und Weltraumstationen nach – denn wohin ließe sich wirksamer fliehen, um soziale Machtspiele und Gängeleien hinter sich zu lassen, als ins menschenleere All?³

Ähnlich entrückt wirken die zahlreichen Stühle und Sessel Vladimir Kagans aus den frühen 70er Jahren, deren farbenfroh bezogene, von durchsichtig-klaren Acrylglaswangen gehaltene Sitzflächen kniehoch über der Erde zu driften scheinen.⁴

Förmlich unsichtbar gibt sich das ungepolsterte Sitzmöbelprogramm aus PMMA des dänischen Designers Verner Panton. Grundelement ist ein auch als Fußbank

Kugelsessel aus *Plexiglas*, 1971
Spherical chair made of *Plexiglas*, 1971
Entwurf | Design: Danilo Silvestrin

cushion of silver-colored leather imitates the aesthetics of moon rockets and space stations. What better place to escape social power games and rigid norms than in the uninhabited realms of space?³

The numerous chairs and armchairs designed by Vladimir Kagan in the early 1970s have a similar far-out appearance. Their colorfully upholstered seats with brackets of clear-transparent acrylic seem to drift above the floor at knee level.⁴

Danish designer Verner Panton went one step further. His furniture range made of PMMA without upholstery is positively invisible. The basic element is a stool that can also be used as a footrest. It consists of a curved acrylic sheet that can be turned into a chair or armchair by screw-fastening to similarly made backrests and armrests.⁵ Later, Panton used spherical or oval shades fashioned from crystal-clear PMMA for his pendant lamps manufactured by Louis Poulsen, "VP-Globe" (1969/70), "Elliptical lamp" (1972) and "Pantopendel" (1977).⁶ The housings enclose

verwendbarer Hocker: eine in Form gebogene Acrylglasplatte, aus der sich – durch Anschrauben ähnlich gefertigter Rücken- und Armlehnen – Stühle oder Sessel produzieren lassen.[5] Später verwendet Panton für seine von Louis Poulsen hergestellten Hängeleuchten „VP-Globe" (1969/70), „Ellipsen-Lampe" (1972) und „Pantopendel" (1977) kugel- beziehungsweise eiförmige Ummantelungen aus glasklarem PMMA.[6] Im Innern der Gehäuse befinden sich ausgeklügelte Systeme teils verspiegelter Aluminiumreflektoren, welche die Verteilung des Lichtes regeln. Bei der VP-Globe tritt das Licht größtenteils seitlich aus: Die im Zentrum der Leuchte befindliche Glühlampe ist durch einen leicht nach innen gewölbten Aluminiumzylinder verborgen und strahlt das Licht nach oben und unten auf die konkaven, verchromten Innenflächen zweier Kugelsegmente aus Metall, von wo aus es in den Raum reflektiert wird. Genauso wie Pantons „Flower-Pot" (1968) – nach Poul Hvidberg-Hansen eine Art ›Volkswagen‹ der Leuchten – sind auch seine Acrylglaslampen als Bestandteile

sophisticated systems of partially mirror-coated aluminum reflectors that control light distribution. In the VP-Globe, most of the light is emitted from the side. The incandescent bulb in the center of the lamp is concealed by an aluminum cylinder that flares out slightly at top and bottom and reflects the light up and down onto the concave chrome-plated inner surfaces of two circular metal segments. These reflect the light into the room. Just like Panton's "Flowerpot" (1968) – according to Poul Hvidberg-Hansen, something like the Beetle of lighting fixtures – his acrylic lamps were also conceived as part of comprehensive interior design concepts. Thus, Panton used a whole array of VP-Globes to equip the lobby of Hamburg publishing company Gruner & Jahr. Like Art Nouveau artists, Panton's approach was not to design individual objects but to create entire furnishings with matching shapes and colors. His wallpapers, floor coverings and furniture are designed such that they can be combined with each other in a variety of ways. This, in turn, distinguishes them from

„Acrylglas ist ein magischer Werkstoff – es lässt einen soliden Gegenstand fast unsichtbar erscheinen."

Eero Aarnio

umfassender Innenraumkonzepte gedacht. Die VP-Globe verwendet Panton beispielsweise in großer Stückzahl für die Ausstattung der Lobby des Hamburger Verlagshauses Gruner & Jahr. Ähnlich wie die Künstler des Jugendstils entwirft Panton keine Einzelobjekte, sondern erarbeitet in Form- und Farbgebung aufeinander abgestimmte Gesamteinrichtungen. Dabei sind seine Tapeten, Fußbodenbeläge und Möbel so gestaltet, dass sie sich in vielfältiger Weise miteinander kombinieren lassen, was sie wiederum von den individuellen Innendekorationen der Jahrhundertwende unterscheidet.

Neben Panton nutzen auch zahlreiche andere Designer in den 60er und 70er Jahren die hohe Transparenz und Lichtleitung von Acrylglas für den Entwurf zeittypischer Leuchten. Diese Objekte zeigen eine überaus große Variationsbreite an materialspezifischen Lichteffekten, fungieren dabei aber meist – im Unterschied zur VP-Globe – als ästhetisch eigenständige Skulpturen. Anschauliche Beispiele sind Yonel Lebovicis Tischleuchte „Satellite" (1965), Ennio Lucinis „Cespuglio di Gino" (1968), Ugo

the individual interior decoration at the turn of the 20th century.

Beside Panton, a number of other designers in the 1960s and 1970s took advantage of acrylic's high transparency and light-guiding properties to create contemporary lamps. These showed an amazing variety of material-specific light effects, but most of them acted as stand-alone sculptures, unlike the VP-Globe. Eminent examples are Yonel Lebovici's table lamp "Satellite" (1965), Ennio Lucini's "Cespuglio di Gino" (1968), Ugo La Pietra's "Globo Tissurato" (1966/67), Vico Magistretti's "Mezzachimera" (1969/70) and the "Gherpe" table lamp (1967) by the designerteam Superstudio, offered in white, yellow and pale pink.

While the furnishings mentioned so far reflect the contemporary climate in their celebration of *joie de vivre*, independence and spontaneity (momentary pleasure beyond the world of work and social obligations), other designers focused more on the protest movement's potential for social criticism. This applies to the "Black ST 201" television set (1969) by Marco Zanuso and Richard Sapper, with

La Pietras „Globo Tissurato" (1966/67), Vico Magistrettis „Mezzachimera" (1969/70) sowie die Tischleuchte „Gherpe" (1967) des Designerteams Superstudio, die in Weiß, Gelb und Rosa angeboten wird.

Während die bisher erwähnten Einrichtungsgegenstände den damaligen Zeitgeist widerspiegeln, indem sie Lebensfreude, Ungebundenheit und Spontaneität – also den Genuss des Moments jenseits von Arbeitswelt und sozialen Verpflichtungen – propagieren, orientieren sich andere Designer stärker am gesellschaftskritischen Potential der Protestbewegung. Das gilt beispielsweise für das Fernsehgerät „Black ST 201" (1969) von Marco Zanuso und Richard Sapper mit einem kubischen Gehäuse aus schwarzem Acrylglas. Sapper selbst charakterisiert die Wirkung des Gerätes wie folgt: „Der allseitig geschlossene Kunstglaswürfel gleicht im ausgeschalteten Zustand einem magischen Stein, übersetzt in unser modernes Technologiezeitalter. Seine äußere Erscheinung erzeugt eine gewisse Irritation, da einerseits die auf der Oberseite des rätselhaften Quaders liegenden Bedienungselemente auf technische Funktionen des Objekts hindeuten, die gewohnte Produktassoziation sich andererseits nicht einstellt, da der Bildschirm hinter einer der schwarzen Würfelseiten verborgen liegt."[7] Damit ist der Black ST 201, der den Bildschirm erst im eingeschalteten Zustand sichtbar werden lässt, ein nachdenklicher Kommentar zur modernen Medienwelt.[8] Möglicherweise hat auch der schwarze Monolith aus Stanely Kubricks Spielfilm „2001: Odyssee im Weltraum" (1968) in der Gestalt und Symbolik des Geräts Spuren hinterlassen.

In der Architektur sorgt PLEXIGLAS® während der Olympischen Spiele 1972 in München für Aufsehen.[9] Bereits Otl Aichers regenbogenfarbenes Corporate Design der Spiele, das in bewusstem Kontrast zu den Olympischen Spielen von 1936 in Berlin steht, trifft in seiner lockeren, Völker verbindenden Art den Nerv der Zeit.[10] Gleiches gilt für das Design der Gebäude: In Zusammenarbeit mit Frei Otto konstruiert das Stuttgarter Architektenteam

Satztische aus *Plexiglas*, 1972
Nest of tables made of *Plexiglas*, 1972
Entwurf | Design: Wilfried Haase

Kassenboxen aus *Plexiglas*, Handelshof Dutenhofen, 1976
Cash desk enclosures made of *Plexiglas*, Handelshof Dutenhofen, 1976

its cubic housing made of black acrylic. Sapper himself described the effect of the set as follows: "This synthetic glass cube closed on all sides looks like the modern technological equivalent of a stone with magical powers. Its outer appearance is slightly confusing, because the top side of the mysterious cube with its operating controls hints at the object's technical function. But it does not have the usual product association because the screen is concealed behind one of the cube's black faces."[7] The Black ST 201, which only reveals the screen when it is switched on, thus becomes a thought-provoking comment on modern media.[8] The black monolith in Stanley Kubrick's movie "2001: A Space Odyssey" (1968) may well have left its mark on the shape and symbolism this appliance.

On the architectural stage, PLEXIGLAS® caused a furore at the 1972 Munich Olympic Games.[9] Otl Aicher's rainbow

> "Acrylic is a magical material –
> it makes a solid object appear nearly invisible."
> Eero Aarnio

corporate design for the games – in intentional contrast to the 1936 Olympic Games in Berlin – matched the mood of the moment with its relaxed multicultural style.[10] The same applies to the building design. In cooperation with Frei Otto, Stuttgart architects Behnisch & Partner constructed a light-filled tent roof made of acrylic whose transparency and ethereal curves lent shape to the games' claim to freedom.[11] Although Otto himself had a very ambivalent attitude to the construction[12], his name is still mainly associated with the roof of the Olympic Stadium.

At the 1968 Munich Construction Show, Röhm & Haas GmbH presented the prototype of the 'bathroom-cum-living room' (*Wohnbad*) in opaque beige-colored *Plexiglas*. It was designed by Matthias Janssen, a professor at Hanover Technical University's Institute for Industrial Design. In

Behnisch & Partner als Überdachung des Münchner Olympiastadions ein lichtdurchflutetes Zeltdach aus Acrylglas, das dem freizügigen Anspruch der Spiele in seiner Transparenz und geschwungenen Leichtigkeit atmosphärisch Gestalt verleiht.[11] Obwohl Ottos Verhältnis zu dem Bau äußerst zwiespältig ist[12], wird sein Name bis heute vor allem mit dem Olympiadach in Verbindung gebracht.

1968 stellt die Röhm & Haas GmbH auf der Münchner Baumesse den Prototyp eines so genannten Wohnbades aus hautfarben opakem *Plexiglas* vor. Der Entwurf stammt von Matthias Janssen, der am Institut für Industrielle Formgebung der Technischen Hochschule Hannover lehrt. In einer Sondernummer der Firmenzeitschrift „Röhm & Haas Spektrum" erklärt das Unternehmen die Zielsetzung, die es mit dem neuen Bädertyp verbindet: „Professor Kyra von der Universität Pennsylvania (USA) hat festgestellt, dass der Baderaum hinter der Wohnraumentwicklung um etwa 40 Jahre hinterherhinkt. Das zu ändern, war unser Ziel. ... Das Ergebnis heißt ›Wohnbad aus *plexiglas*‹. In diesem Aufenthaltsraum für die Familie ist an alles gedacht. Denn in ihm kann der Mensch das tun, was er braucht, um die Anforderungen des Alltags

Kinderbett aus *Plexiglas*, 1974
Child's bed made from *Plexiglas*, 1974
Entwurf | Design: Ernst Theuerkauff

Tanzfläche aus *Plexiglas*, Discothek Barkusky Herzebrock, 1973
Plexiglas dance floor, Barkusky discotheque Herzebrock, 1973

Münchner Olympiastadion mit Lichtdach aus *Plexiglas*, 1972 (S. 76/77)
Munich's Olympic Stadium with light-transmitting roof made of *Plexiglas*, 1972 (pp. 76–77)
Entwurf | Design: Frei Otto, Günter Behnisch

a special edition of the corporate magazine "Röhm & Haas Spektrum," the company explained the aim it pursued with the new type of bathroom: "Professor Kyra from Pennsylvania University (USA) has established that the bathroom lags about 40 years behind the living room in terms of comfort. We wanted to change all that. ... The result is the 'living bathroom made of *plexiglas*'. We have thought of everything in this luxury haven where the whole family can relax. It's a place where people can do whatever they need to switch off and take time out from the demands of their daily routine. They can bathe, rest, chat or read, exercise, listen to music or watch TV. Nothing disturbs them, everything invites them to stay put – except for

gelassener zu überstehen. Er kann baden, ruhen, reden, lesen, Gymnastik treiben, Musik hören und fernsehen. Nichts vertreibt ihn, alles lädt zum Bleiben – falls nicht wieder einmal unaufschiebbare Termine drängen."[13] Selbst auf den Wunsch nach Alkoholgenuss ist das Wohnbad mit einer integrierten Bar eingestellt. Obwohl Janssens Entwurf klar im Trend der freizeithungrigen 60er Jahre liegt und zum Markterfolg farbiger Sanitärobjekte aus *Plexiglas* beiträgt, kann sich die Idee des Wohnbades im engeren Sinne nicht breitenwirksam durchsetzen. Aber wer weiß, vielleicht erhält sie in Zeiten des aktuellen Fitness- und Wellness-Booms eine neue Chance.

the usual dates that can't be postponed."[13] Thought was even given to the wish for a drink or two when designing this bathroom haven, with its integrated bar. Although Janssen's design bears witness to the leisure-hungry 1960s and helped promote the market success of colored *Plexiglas* sanitaryware, the idea of the 'bathroom-cum-living room' as such never really caught on. But who knows, perhaps it will now, when people are devoting more time to fitness and wellness than ever before.

Wohnbad aus *Plexiglas*, 1968
'Wohnbad' made of *Plexiglas*, 1968
Entwurf | Design: Matthias Janssen

Anmerkungen

1 Vgl. Penny Sparke: Plastics and Pop culture. In: The Plastics Age. From Modernity to Post-Modernity. Hg. P. Sparke. London 1990. S. 93–103; Philippe Decelle, Diane Hennebert und Pierre Loze: L'utopie du tout plastique, 1960–1973. Brüssel 1994; Hans Ulrich Kölsch: Objekt-Design in Kunststoff – die 60er Jahre des 20. Jahrhunderts. In: Die 60er. Positionen des Designs. Hg. G. Breuer, A. Peters, K. Plüm. Köln 2000. S. 158–167.

2 Markus Caspers: Jugendkultur, Pop und Design. In: Im Designerpark. Hg. K. Buchholz, K. Wolbert. Darmstadt 2004. S. 184.

3 Vgl. Gerda Breuer: Die Raumfahrt-Dekade. Mediale Mythisierung des Designs. In: Die 60er. Positionen des Designs. Hg. G. Breuer, A. Peters, K. Plüm. Köln 2000. S. 138–143.

4 Vgl. Vladimir Kagan: A Lifetime of Avant-Garde Design. New York 2004. S. 145: „Plexiglas gewann jetzt eine eigene Qualität, obwohl ich es bereits in den 60er Jahren häufig verwendet hatte. ... Mich interessierte das Material weniger als Mittel zum Zweck, sondern vor allem wegen seiner Eigenschaft, meinen Möbeln Leichtigkeit zu verleihen. Ich arbeitete mit Illusionen, die die Möbel ›unsichtbar‹ über dem Boden schweben ließen und so ein Stück optischer Zauberei verwirklichten."

5 Vgl. Verner Panton. Das Gesamtwerk. Hg. M. Remmele, A. von Vegesack. Kat. Vitra Design Museum. Weil am Rhein 2000. S. 244.

6 Vgl. Poul Hvidberg-Hansen: Die Quelle des Lichtes. In: Verner Panton. Das Gesamtwerk. Hg. M. Remmele, A. von Vegesack. Kat. Vitra Design Museum. Weil am Rhein 2000. S. 100–124.

7 Richard Sapper in einer Fernsehsendung des WDR, zitiert nach S. Diederich: Gesichter des Objekts – Wandelbarkeit von Form und Dingcharakter in Entwürfen Richard Sappers. In: Richard Sapper. Kat. Museum für angewandte Kunst. Köln 1993. S. 51.

8 Vgl. Hartmut Jatzke-Wigand: Brionvega – die Technik in ihrer schönsten Form. In: Die 60er. Positionen des Designs. Hg. G. Breuer, A. Peters, K. Plüm. Köln 2000. S. 68–72.

9 Zu den Verwendungsmöglichen von Acrylglas in der Architektur allgemein vgl. Ralph Montella: Plastics in Architecture. A Guide to Acrylic and Polycarbonate. New York, Basel 1985.

10 Vgl. Nadine Schreiner: Das visuelle Erscheinungsbild der Olympischen Spiele 1972 in München. In: Im Designerpark. Hg. K. Buchholz, K. Wolbert. Darmstadt 2004. S. 620–623.

11 Zu den technischen Details des Daches vgl. folgende Beiträge in Röhm Spektrum. 7 (1971): Manfred Buck: Olympiade unter *Plexiglas*. S. 4–6; Dieter Müller: Das Zeltdach aus *Plexiglas*. Die Anlage. Das Seilnetz. Die Verlegung von *Plexiglas* 215 gereckt. S. 7–10; Udo Fischer: Das Zeltdach aus *Plexiglas*. Lichttechnische Gesichtspunkte. S. 11–14; Franz Esser: Das Zeltdach aus *Plexiglas*. Safety first. S. 14–16; Jürgen Hennig: Das Zeltdach aus *Plexiglas*. *Plexiglas* 215 gereckt. Eigenschaften und Eignung. S. 17–19.

12 Im Interview mit Heinrich Klotz äußert Frei Otto: „Lieber Herr Klotz, da reißen Sie etwas an, das bis heute unverdaut ist. Ich habe in meinem Leben immer nur phantastische Kooperation mit den Kollegen Ingenieuren gehabt. Einzig dieses eine Mal lief es falsch. Ich bin noch im Zorn! Ich kann nicht objektiv über das Olympiadach sprechen. Meine Eindrücke sind zu frisch und zu subjektiv. Der Abstand, den ich seit 1970 gewinnen konnte, ist noch zu klein. Dieses Dach hat mir zumindest bis heute in gewisser Weise geschadet, weil es von dem ablenkte, was ich anstrebte. Ich wollte übrigens nicht für Olympia bauen, ich wurde damals praktisch überrumpelt. Unser Team hat sich nicht beim Wettbewerb beteiligt. Die moderne Olympiade hat mit Olympia und Sport wenig zu tun. Es ist ein Kolossaltheater römischer Abstammung, Gladiatorenkämpfe, die ihre Akteure verschleißen. Und olympische Bauten des 20. Jahrhunderts sind Türme von Babylon, die entweder von selbst zerfallen oder ihre Baumeister zerbrechen." (Gespräch mit Frei Otto. In: Heinrich Klotz: Architektur in der Bundesrepublik. Frankfurt a. M., Berlin, Wien 1977. S. 219/220).

13 Röhm & Haas Spektrum. Extrablatt. Schritt in die Zukunft, Wohnbad aus *Plexiglas*. Darmstadt 1968. S. 2. Zum Wohnbad vgl. auch Anonymus: Das Wohnbad aus *Plexiglas*. In: Röhm Spektrum. 2 (1968). S. 8–13; Alexander Kira: The Bathroom. New York 1976. S. 172.

Notes

1 See Penny Sparke, "Plastics and Pop culture," in *The Plastics Age*, From Modernity to Post-Modernity, ed. Penny Sparke (London: Victoria & Albert Museum, 1990), p. 93–103; Philippe Decelle, Diane Hennebert and Pierre Loze, *L'utopie du tout plastique*, 1960–1973 (Brussels: Fondation pour l'Architecture, 1994); Hans Ulrich Kölsch, "Objekt-Design in Kunststoff – die 60er Jahre des 20. Jahrhunderts," in *Die 60er*, Positionen des Designs, ed. Gerda Breuer, Andrea Peters, Kerstin Plüm (Cologne: Wienand, 2000), pp. 158–167.

2 Markus Caspers, "Jugendkultur, Pop und Design," in *Im Designerpark*, ed. Kai Buchholz, Klaus Wolbert (Darmstadt: Häusser, 2004), p. 184.

3 See Gerda Breuer, "Die Raumfahrt-Dekade, Mediale Mythisierung des Designs," in *Die 60er*, Positionen des Designs, ed Gerda Breuer, Andrea Peters, Kerstin Plüm (Cologne: Wienand, 2000), pp. 138–143.

4 See Vladimir Kagan: *A Lifetime of Avant-Garde Design* (New York: Pointed Leaf Press, 2004), p 145: "Plexiglas had finally come into its own, though I had already used it extensively in the sixties. ... I was less intrigued with the material as a means to an end but was really impressed with its ability to lighten my furniture. I was working with illusions, making the furniture float 'invisibly' off the ground and achieving a bit of visual magic."

5 See Verner Panton, *Das Gesamtwerk*, ed. Mathias Remmele, Alexander von Vegesack (Weil am Rhein: Vitra Design Museum, 2000), p. 244.

6 See Poul Hvidberg-Hansen, "Die Quelle des Lichtes," in *Verner Panton*, Das Gesamtwerk, ed. Mathias Remmele, Alexander von Vegesack (Weil am Rhein: Vitra Design Museum, 2000), pp. 100–124.

7 Richard Sapper in a programme on Germany's WDR channel, courtesy translation of quote according to S. Diederich, "Gesichter des Objekts – Wandelbarkeit von Form und Dingcharakter in Entwürfen Richard Sappers," in *Richard Sapper* (Cologne: Museum für angewandte Kunst, 1993), p. 51.

8 See Hartmut Jatzke-Wigand, "Brionvega – die Technik in ihrer schönsten Form," in *Die 60er*, Positionen des Designs, ed. Gerda Breuer, Andrea Peters, Kerstin Plüm (Cologne: Wienand, 2000), pp. 68–72.

9 On the potential uses of acrylic in architecture in general, see Ralph Montella, *Plastics in Architecture*, A Guide to Acrylic and Polycarbonate (New York, Basel: Dekker, 1985).

10 See Nadine Schreiner, "Das visuelle Erscheinungsbild der Olympischen Spiele 1972 in München," in *Im Designerpark*, ed. Kai Buchholz, Klaus Wolbert (Darmstadt: Häusser, 2004), pp. 620–623.

11 On the technical details of the roof, see the following articles in *Röhm Spektrum* 7 (1971): Manfred Buck, "Olympic games under *Plexiglas*," pp. 4–6; Dieter Müller, "The *Plexiglas* tent roof, The installation, The cable network, The laying of *Plexiglas* 215 stretched," pp. 7–10; Udo Fischer, "The *Plexiglas* tent roof, Optical aspects," pp. 11–14; Franz Esser, "The *Plexiglas* tent roof, Safety first," pp. 14–16; Jürgen Hennig, "The *Plexiglas* tent roof, *Plexiglas* 215 stretched: properties and applicability," pp. 17–19.

12 In an interview with Heinrich Klotz, Frei Otto said: "Dear Mr. Klotz, there you touch on a subject that still rankles with me today. All my life, I have always enjoyed fantastic cooperation with my fellow engineers. This was the only time everything went wrong. I'm still furious about it. I can't speak objectively about the roof of the Olympic Stadium, my impressions are too fresh and too subjective, and I haven't been able to distance myself enough since 1970. This roof has damaged my reputation to a certain extent because it detracted attention from what I was trying to achieve. Incidentally, I didn't want to build anything for the Olympics, I was more or less caught unawares. Our team did not take part in the competitive bidding. The modern Games have little to do with Olympia and sport – they are a colossal Roman theater with gladiator fights that wear down their protagonists. And Olympic buildings in the 20th century are towers of Babylon that either collapse on their own or destroy their architects." (courtesy translation of conversation with Frei Otto, in Heinrich Klotz, *Architektur in der Bundesrepublik* (Frankfurt a. M., Berlin, Vienna: Ullstein, 1977), pp. 219–220).

13 *Röhm & Haas Spektrum*, supplement, Schritt in die Zukunft, Wohnbad aus *Plexiglas* (Darmstadt: Röhm & Haas, 1968), p. 2. On the subject of the 'bathroom-cum-living room', see also anonymous, "Das Wohnbad aus *Plexiglas*," *Röhm Spektrum* 2 (1968): 8–13; Alexander Kira, *The Bathroom* (New York: Viking Press, 1976), p. 172.

Mechanische Eigenschaften

Vergleicht man die mechanischen Eigenschaften von Acrylglas mit denen von anorganischem Fensterglas, ergibt sich folgendes Bild:

	PMMA	Glas
Dichte in g/cm^3	1,12–1,18	2,4–2,7
→Zugfestigkeit in N/mm^2	60–80	30
→Druckfestigkeit in N/mm^2	120	900

Acrylglas ist deutlich leichter und bruchsicherer als herkömmliches Fensterglas, weshalb es häufig im Fahrzeug- und Flugzeugbau eingesetzt wird, wo niedrige Kraftstoffkosten und die Sicherheit der Fahrgäste im Vordergrund stehen. Auch wenn PMMA über die höchste Oberflächenhärte und Kratzfestigkeit aller Thermoplaste verfügt, schneidet Silikatglas bei diesem Merkmal besser ab. Durch geeignete Beschichtungen lässt sich die Oberflächenhärte aber fast auf die von anorganischem Glas anheben. Mittels winziger Gummipartikel, die dem Acrylglas während der Herstellung hinzugefügt werden, kann auch die →Schlagzähigkeit noch um ein Mehrfaches erhöht werden. Eine weitere Variante des Materials ist das gereckte PMMA. Durch das biaxiale Auseinanderziehen (Recken) einer erwärmten Platte und das ›Einfrieren‹ der Spannungen in diesem neuen Format erhält das Material verbesserte mechanische Festigkeiten. Eine solche Materialtype wurde für das Münchner Olympiastadion verwendet.

Mechanical Properties

The mechanical properties of acrylic compare as follows with those of inorganic window glass:

	PMMA	Glass
Density in g/cm^3	1.12–1.18	2.4–2.7
→Tensile strength in N/mm^2	60–80	30
→Compressive strength in N/mm^2	120	900

Acrylic is much lighter in weight and more resistant to breakage than conventional window glass. That is why it is frequently used in vehicle and aircraft construction, where low fuel costs and passenger safety are major considerations. Although PMMA offers the highest surface hardness and scratch resistance of all thermoplastics, silicate glass is better still in this respect. However, the surface hardness of acrylic can be raised to almost the same level as that of glass by means of suitable coatings. By adding minute rubber particles to the acrylic during manufacture, the →impact strength can be increased several times over. A further variant of the material is stretched PMMA. Biaxial stretching of the heated sheet and the 'freezing in' of the stresses in the new sheet format lend improved mechanical strength to the material. This grade of material was used for the roof of Munich's Olympic Stadium.

Cat. 60
Hängesessel „Bubble Chair", 1968
"Bubble Chair," 1968
Entwurf | Design: Eero Aarnio

Cat. 57
Tischleuchte „Satellite", 1965
"Satellite" table lamp, 1965
Entwurf | Design: Yonel Lebovici

Cat. 61
Einrichtungselemente der „Tunnel-Discoteca", Hotel Grifone, Bozen, 1968
Furnishing elements of the "Tunnel-Discoteca," Hotel Grifone, Bozen, 1968
Entwurf | Design: Cesare Casati, Emmanuele Ponzio, Gino Marotta

Cat. 59
Tischleuchte „Gherpe", 1967
"Gherpe" table lamp, 1967
Entwurf | Design: Superstudio (= Gian Piero Frassinelli, Alessandro Magris,
Roberto Magris, Adolfo Natalini, Cristiano Toraldo di Francia)

Cat. 62
Tischleuchte „Cespuglio di Gino", 1968
"Cespuglio di Gino" table lamp, 1968
Entwurf | Design: Ennio Lucini

Cat. 68
Spiegel „Ultrafragola", 1970
"Ultrafragola" mirror, 1970
Entwurf | Design: Ettore Sottsass

Cat. 72
Badezimmer-Hocker, 1971
Bathroom stools, 1971
Entwurf | Design: Vera Röhm

Cat. 58
Bodenleuchte „Globo Tissurato", 1966/67
"Globo Tissurato" floor lamp, 1966/67
Entwurf | Design: Ugo La Pietra

Cat. 65
Deckenleuchte Nr. 16705 „VP-Globe", 1969/70
Ceiling lamp No. 16705 "VP-Globe," 1969/70
Entwurf | Design: Verner Panton

Cat. 71
Tonmöbel „Vision 2000", 1971
"Vision 2000" audio cabinet, 1971
Entwurf | Design: Thilo Oerke

Cat. 64
Fernsehgerät „Black ST 201", 1969
"Black ST 201" television set, 1969
Entwurf | Design: Marco Zanuso, Richard Sapper

Cat. 70
Souvenir Maxi-Kugelschreiber „Fernsehturm Berlin", um 1970
Jumbo ballpoint pen souvenir "Fernsehturm Berlin," ca. 1970

Cat. 75
Zettelkasten, Werbemittel für Radio DDR, 70er Jahre
File-card box, giveaway for Radio DDR, 1970s

95

Postmoderne Spielereien
Die 80er Jahre

Postmodern Whimsicalities
The 1980s

Auf der Mailänder Möbelmesse 1981 ereignet sich eine Designrevolution. Die Gruppe Memphis, von Ettore Sottsass ins Leben gerufen, präsentiert hier Möbel und Leuchten, die weder einem einheitlichen Stil noch klassischen gestalterischen Normen folgen. Viele der gezeigten Objekte sind mit wild gemusterten Laminaten überzogen, unter denen das eigentliche Trägermaterial verschwindet: ein krasser Verstoß gegen das lange Zeit gepflegte Dogma der Materialgerechtigkeit, wonach sich die besonderen Eigenschaften der verwendeten Werkstoffe in der Gestaltung niederschlagen sollen. Bei Memphis verschwimmen die Grenzen zwischen Design und Kunst. Nicht mehr die Funktion der Gegenstände steht im Vordergrund, sondern der spielerische Umgang mit dem Material, der effektvolle Einsatz starker Farben und Farbkontraste sowie die ungewöhnliche, verrückte Formgebung – ein erfrischend frecher Angriff auf festgefahrene Konventionen.

In 1981, the Milan Furniture Show heralded a real design revolution. At this show, the Memphis Group created by Ettore Sottsass presented furniture and lamps that followed neither classical design standards nor a uniform style. Many of the displayed objects were covered with riotously patterned laminates that completely submerged the substrate material. This was a flagrant break with the long-cherished dogma of doing justice to materials and making design reflect their special properties. Memphis blurred the borders between design and art: The emphasis was no longer on the function of the objects, but on the playful handling of the material, the effective use of vivid and contrasting colors and unusual, zany shapes – a refreshingly irreverent attack on stolid conventions.

The group around Sottsass, including Michele De Lucchi, Matteo Thun, Michael Graves and Nathalie du Pasquier, owes its name purely to coincidence. During the meeting at which it was founded, Bob Dylan's song "Stuck Inside of Mobile with the Memphis Blues Again" was playing in the background. This gave Sottsass the spontaneous idea of calling the new group "Memphis," a name that neatly encompasses ancient Egyptian culture (Memphis near Cairo) and rock 'n' roll, Elvis Presley style (Memphis Tennessee).

Konzertflügel aus Acrylglas, um 1985
Concert piano made of acrylic, ca. 1985

Der Name der Gruppe, zu der neben Sottsass unter anderem Michele De Lucchi, Matteo Thun, Michael Graves und Nathalie du Pasquier zählen, verdankt sich einem Zufall. Während des Gründungstreffens läuft im Hintergrund Bob Dylans „Stuck Inside of Mobile with the Memphis Blues Again", was Sottsass spontan auf die Idee bringt, die neue Gruppe „Memphis" zu nennen, da der Name gleichzeitig für altägyptische Kultur (Memphis bei Kairo) und Rock 'n' Roll à la Elvis Presley (Memphis Tennessee) steht – eine Kombination von Erhabenem und Trivialem, die zum Kennzeichen des neuen Designs wird.[1]

Mit seiner eklektizistischen Formensprache reiht sich Memphis in die Traditionslinie des Historismus und Neohistorismus ein.[2] Der Anspruch des Bauhauses und der Ulmer Schule, der modernen rationalen Welt ein adäquates Antlitz zu verleihen, weicht der Vorstellung, dass Moderne gar kein einheitliches Kulturgebilde ist, sondern ein Nebeneinander unterschiedlicher, miteinander unvereinbarer Lebensformen. Diese Auffassung teilt Memphis mit der philosophischen Postmoderne, die nicht mehr an verbindliche Erkenntnisstandards glaubt.[3] Das Design der 80er Jahre wird deshalb oft selbst als postmodern bezeichnet.[4] Typisch für die neuen Entwürfe ist, dass sie gleichsam zu sprechen beginnen, nicht nur einfache materielle Gegenstände sind, sondern auch Zeichen, mit denen sich eine Aussage oder Frage verbindet. Viele von ihnen sollen im Benutzer Gedanken darüber auslösen, warum Möbel, Haushaltsgeräte und Bushaltestellen gerade die Gestalt besitzen, die sie haben, ob die Massenprodukte der Industriegesellschaft allgemein gültigen Regeln der Gebrauchsfreundlichkeit gehorchen und damit reinen Werkzeugcharakter besitzen oder ob sie vielleicht selbst kulturelle Umgangsformen mitbestimmen.[5]

This combination of high art and trivial culture became the hallmark of the new design.[1]

With its eclectic idiom, Memphis fits into the tradition of historicism and neohistoricism.[2] The claim of Bauhaus and the Ulm School of Design – to lend a fitting face to the modern, rational world – gave way to the view of modernism as the juxtaposition of different and mutually incompatible forms of life rather than a common cultural construct. Memphis shared this view with philosophical post-modernism that no longer believed in general epistemological standards.[3] The design of the 1980s is therefore often termed post-modern.[4] Typical of the new designs is that they have learned to speak, as it were. They are no longer simply material objects, but symbols that stand for an assertion or question. Many of them are meant to prompt their users to ask why furniture, household appliances and bus stops should be the shape they are, whether the mass-produced items of industrial society obey generally applicable rules of user friendliness and thus have a purely tool-like character, or whether they exert an impact on cultural practices in themselves.[5]

Japanese designer Shiro Kuramata's chair "Miss Blanche," widely considered as the aesthetic climax of post-modern acrylic design, is an impressive example of such 'speaking' objects. In 1951, Elia Kazan's movie "A Streetcar Named Desire," adapted from the eponymous play by Tennessee Williams, won four Oscars with Vivien Leigh and Marlon Brando in the leading roles. Leigh played the part of Blanche Du Bois, a fragile and faded Southern belle who tries to veil

> „Kuramatas ›Miss Blanche‹ entführt uns ins Reich des Metaphysischen – die Rosen scheinen zum Greifen nahe, aber das starke Acrylglas hindert uns daran, sie zu berühren."
>
> Tadashi Yokoyama

Discothek-Einrichtung aus *Plexiglas*, 1989
Discotheque furnishing made of *Plexiglas*, 1989
Entwurf | Design: Achim Bredow

Ladeneinrichtung aus *Plexiglas*, Schuhhaus Lahr Koblenz, 1980
Store fixtures made of *Plexiglas*, Schuhhaus Lahr Koblenz, 1980

Zeichenschablonen aus *Plexiglas*, 1987
Plexiglas stencils, 1987

Ein prägnantes Beispiel für solche ›sprechenden‹ Gegenstände ist der Stuhl „Miss Blanche" des japanischen Designers Shiro Kuramata – das wohl bedeutendste postmoderne Designobjekt aus Acrylglas. 1951 wird Elia Kazans Spielfilm „A Streetcar Named Desire" („Endstation Sehnsucht") nach dem gleichnamigen Drama von Tennessee Williams mit vier Oscars ausgezeichnet. Die Hauptrollen spielen Vivien Leigh und Marlon Brando. Leigh verkörpert die Figur der Blanche Du Bois, einer zerbrechlichen, gestrandeten Frau, die unter gekünstelten Manieren und zarten Spitzenkleidern eine gescheiterte Existenz verbirgt. Von der gleichzeitigen Suche nach Geborgenheit und erotischen Abenteuern zerrissen, gerät die aus guten Verhältnissen stammende Blanche in Konflikt mit der bürgerlichen Gesellschaft und verfällt am Ende dem Wahnsinn.

Der Katalog zur Designsammlung des Museum of Modern Art in New York beschreibt Kuramatas Entwurf knapp und präzise: „Bei diesem Stuhl verarbeitet Kuramata künstliche Rosen in transparenten Acrylblöcken. Die Blumen werfen Schatten auf den Boden und scheinen

her failed existence behind affected manners and gauzy dresses. Torn between her longing for security and erotic adventure, Blanche, who stems from a family with aristocratic pretensions, comes into conflict with bourgeois society and in the end goes insane.

In its design collection catalogue, the New York Museum of Modern Art sums up Kuramata's design as follows: "In this chair, Kuramata has enclosed artificial roses in transparent blocks of acrylic. The flowers cast shadows on the floor and appear to float immobilized in time and space. The dreamlike picture of roses 'in the air' seems to contradict our expectation that the chair, with its inscrutable visible construction, is capable of bearing our weight. This surreal effect imbues the object with dramatic suspense."[6] This direct visual impression is supplemented

wie in Zeit und Raum fixiert, schwerelos zu schweben. Das traumhafte Bild von Rosen ›in der Luft‹ scheint unsere Erwartung zu widerlegen, dass der Stuhl mit seiner schwer zu erfassenden sichtbaren Konstruktion unser Gewicht aushält – eine surreale Wirkung, die das Objekt mit dramatischer Spannung erfüllt."[6] Neben diesen unmittelbaren anschaulichen Eindruck tritt die symbolische Funktion des Stuhls, der mit seinem assoziativen Titel zwischen Gebrauchsgegenstand und künstlerischer Skulptur changiert. Eindeutig ist er als Metapher der Blanche Du Bois zu begreifen: So wie hinter der mühsam aufrecht erhaltenen Fassade der Filmfigur nach und nach triviale Sehnsüchte zum Vorschein kommen, entpuppen sich die Rosen im Herzen des eleganten Möbelstücks bei näherem Hinsehen als unecht. Auch die filigrane Zerbrechlichkeit der tragischen Antiheldin findet in Kuramatas zart und leicht anmutendem Objekt eine feinsinnige Entsprechung. Am bedeutsamsten für dessen Gesamtaussage ist aber vielleicht, dass der ätherische

by the subtle symbolic function of the chair, which, due to its evocative title, morphs from everyday item to artistic sculpture. It is clearly intended as a metaphor for Blanche Du Bois. Just as the movie character gradually betrays the trivial desires behind her painstakingly preserved facade, the roses at the heart of the elegant chair reveal themselves, upon closer inspection, to be artificial. Even the fragility of the tragic anti-heroine is subtly mirrored by Kuramata's delicate, lightweight object. But perhaps the most significant aspect of its overall statement is that the ethereal chair is equally out of place in the menacing world of Chernobyl and AIDS as fragile plantation owner's daughter Blanche was in the aggressive climate of America's Old South after the war.

In 1973, the plastics euphoria of the 1960s and early 1970s was muted by the oil crisis. Furniture manufacturers in particular were hard-hit by this turning point, as critical consumers became markedly reticent toward the synthetic

Stuhl genauso wenig in die bedrohliche Welt von Tschernobyl und Aids passt wie die fragile Gutsbesitzertochter Blanche in die aggressiven amerikanischen Südstaaten der Nachkriegszeit.

1973 wird die Kunststoff-Euphorie der 60er und frühen 70er Jahre von der Ölkrise gedämpft. Vor allem die Möbelhersteller sind von diesem Einschnitt betroffen, da hier kritische Verbraucher auf künstliche Materialien mit besonderer Zurückhaltung reagieren.[7] Im Industriedesign setzt sich der Siegeszug der vielseitig verwendbaren Kunststoffe dagegen ungebrochen fort. Technologische Fortschritte ermöglichen in den 80er Jahren neue Verfahren der Oberflächenbehandlung und Lösungen ›nach Maß‹ für die verschiedensten Anwendungsprofile.[8]

Während das italienische und französische Design den Kunststoffen auch im Wohnbereich ein Comeback beschert, tut sich das Neue deutsche Design in dieser Zeit mit künstlich erzeugten Materialien nach wie vor schwer. Seine Vertreter – Volker Albus, Andreas Brandolini, Axel Kufus, Wolfgang Laubersheimer und andere – kehren im Gegenteil zu handwerklichen Fertigungsmethoden und bewusst ›archaisch‹ wirkenden Materialien wie Holz, Stein, Stahl und Glas zurück. So erweisen sich die Entwürfe der provokanten deutschen Spielart des postmodernen Designs trotz spektakulärer Auftritte in den Medien als für die Serienproduktion untauglich.[9]

Eine Ausnahme in der Materialwahl bildet der – allerdings auch im Stadium des Prototyps verbliebene – Raumteiler „Fish 'n Chips" des Designerduos Ad Us. In ihrem Buch „Design-Bilanz" attestieren Volker Albus und Christian Borngräber dem Entwurf besondere technische Raffinesse: „Zum ersten Mal ist es gelungen, eine Magnettafel, die bisher immer undurchsichtig war, transparent zu machen. Magnetisierbare Einschlüsse wurden, ohne die

materials.[7] In industrial design, though, the versatile plastics went from strength to strength. Technological advances in the 1980s enabled new surface treatment processes and 'tailormade' solutions for a wide variety of application profiles.[8]

Whereas Italian and French design also reinstated plastics in the living room, the New German Design of this era still had its problems with synthetic materials. Its proponents – Volker Albus, Andreas Brandolini, Axel Kufus, Wolfgang Laubersheimer and others – returned to craftsmanlike fabrication methods and consciously chosen 'archaic' materials like wood, stone, steel and glass. Despite

> "Kuramata's 'Miss Blanche' lures us into the metaphysical – the roses seem so close but the thick acrylic stops us from touching them."
> Tadashi Yokoyama

spectacular appearances in the media, the provocative German products of postmodern design proved unsuitable for serial production.[9]

The "Fish 'n Chips" partition designed by the Ad Us duo (which never advanced beyond a prototype, however) opted for a different material. In their book "Design-Bilanz," Volker Albus and Christian Borngräber point out the special technical sophistication of the design: "This is the first time a magnetic board has been designed with a transparent material. Previous versions were always opaque. Here, magnetizable inclusions are irregularly cast in the acrylic panel. They consist of metal scrap from stamping and drilling, and offer a play of colors ranging from gray aluminum and blue steel to rose gold."[10] With its metal inclusions, the decorative partition has a certain sight-screening effect despite its high transparency. Thanks to its magnetic properties, it can be used in offices to spontaneously hang up work results. This is an extremely

Wasserrutsche aus *Plexiglas*, Königstherme Königsbrunn, 1988
Plexiglas water slide, Königstherme Königsbrunn, 1988

gesamte Fläche des Paneels gleichmäßig zu beanspruchen, in Acryl eingegossen. Es sind Metallabfälle vom Stanzen und Bohren, die zudem ein Farbenspiel von Aluminiumgrau über Stahlblau bis Rotgold zeigen."[10] Durch die Metalleinschlüsse bietet der dekorative Raumteiler trotz seiner hohen Lichtdurchlässigkeit einen gewissen Sichtschutz. Dank seiner magnetischen Eigenschaften lässt er sich im Büro überdies für die spontane, übersichtliche Präsentation von Arbeitsergebnissen nutzen – eine äußerst praktische Verbindung unterschiedlicher Funktionen im selben Gebrauchsgegenstand. Aber damit nicht genug, als ein Werk des Neuen deutschen Designs fungiert „Fish 'n Chips" gleichzeitig als pfiffiges Zeichen: Mittels der verarbeiteten Metallreste, die direkt aus der

Lärmschutzwand aus *Plexiglas*, Hamburg-Elbbrücken, 1988
Plexiglas noise barrier, Hamburg-Elbbrücken, 1988
Entwurf | Design: Oskar Lehmann

Daimler Benz Centomobil aus *Plexiglas*, 1985
Daimler Benz Centomobil made of *Plexiglas*, 1985

Produktion stammen, verweist das Büromöbel auf die arbeitsteilige Organisation der technischen Zivilisation und wird damit zum Sinnbild der modernen Gesellschaft, welche – so sehen es Kulturkritiker wie John Ruskin und Karl Marx bereits Mitte des 19. Jahrhunderts – das Leben eben auch entmenschlicht.

practical combination of different functions in one and the same everyday item. But that is not all – as a work of New German Design, "Fish 'n Chips" also broadcasts a clever message. By using metal scrap straight from the factory, the office furnishing refers to the division of labor in technical civilization and thus becomes a symbol for modern society, which (as culture critics like John Ruskin and Karl Marx already recognized in the mid-19th century) has a dehumanizing effect.

Anmerkungen

1 Vgl. Jan Burney: Ettore Sottsass. London 1991. S. 143–189.

2 Zum Neohistorismus vgl. z. B. Renate Ulmer: Anspruchsvolles Wohndesign. In: Im Designerpark. Hg. K. Buchholz, K. Wolbert. Darmstadt 2004. S. 644–661.

3 Vgl. z. B. Jean-François Lyotard: La condition postmoderne. Paris 1979; Ders.: Le différend. Paris 1983.

4 Vgl. Thomas Hauffe: Das Neue deutsche Design und die Postmoderne. In: Im Designerpark. Hg. K. Buchholz, K. Wolbert. Darmstadt 2004. S. 192–199.

5 Vgl. z. B. Dagmar Steffen: Der Korkenzieher – ein Fall für zwei? In: Im Designerpark. Hg. K. Buchholz, K. Wolbert. Darmstadt 2004. S. 804–807. Zur Frage der Gebrauchsfreundlichkeit vgl. Kai Buchholz Brauchbarkeit, Lebensformen und unsichtbares Design. In: Im Designerpark. Hg. K. Buchholz, K. Wolbert. Darmstadt 2004. S. 96–105.

6 Paola Antonelli: Design. Die Sammlung des Museum of Modern Art. München, Berlin, London, New York 2003. S. 275.

7 Vgl. Josef Straßer: Utopien in Plastik. Die Kunststoff-Euphorie der sechziger und frühen siebziger Jahre. In: Josef Straßer und Renate Ulmer: Plastics + Design. Stuttgart 1997. S. 86.

8 Vgl. z. B. Sylvia Katz: Plastics in the '80s. In: The Plastics Age. From Modernity to Post-Modernity. Hg. P. Sparke. London 1990. S. 145–151; Oliver Frank: Veränderung der Deformationsmechanismen bei schlagzäh modifiziertem *Plexiglas*. In: Röhm Spektrum. 34 (1986). S. 21–24; Barbara Geppert: *Plexiglas* Folien F für die Display-Technik. In: Röhm Spektrum. 37 (1989). S. 85/86.

9 Vgl. dazu Josef Straßer: Das langsame Comeback. Die achtziger und neunziger Jahre. In: Josef Straßer und Renate Ulmer: Plastics + Design. Stuttgart 1997. S. 129: „Auch Entwerfer wie Ron Arad …, die überwiegend mit Metall arbeiteten, begannen sich nun häufiger mit Kunststoff zu beschäftigen. Exemplarisch für diese veränderte Einstellung ist sein Wandregal ›Bookworm‹ von 1993: Der Erfolg dieses ursprünglich aus gehärtetem Stahl gefertigten Objektes stellte sich erst mit der Kunststoffversion ein, die, wie er selbst sagt, ›leichter, bunt, transparent, einfacher anzubringen und viel preiswerter ist.‹"

10 Volker Albus und Christian Borngräber: Design-Bilanz. Neues deutsches Design der 80er Jahre in Objekten, Bildern, Daten und Texten. Köln 1992. S. 50.

Notes

1 See Jan Burney, *Ettore Sottsass* (London: Trefoil, 1991), pp. 143–189.

2 On neohistoricism, see for example Renate Ulmer, "Anspruchsvolles Wohndesign," in *Im Designerpark*, ed. Kai Buchholz, Klaus Wolbert (Darmstadt: Häusser, 2004), pp. 644–661.

3 See for example Jean-François Lyotard, *La condition postmoderne* (Paris: Minuit, 1979); *Le différend* (Paris: Minuit, 1983).

4 See Thomas Hauffe, "Das Neue deutsche Design und die Postmoderne," in *Im Designerpark*, ed. Kai Buchholz, Klaus Wolbert (Darmstadt: Häusser, 2004), pp. 192–199.

5 See for example Dagmar Steffen, "Der Korkenzieher – ein Fall für zwei?," in *Im Designerpark*, ed. Kai Buchholz, Klaus Wolbert (Darmstadt: Häusser, 2004), pp. 804–807. On the question of user friendliness, see Kai Buchholz, "Brauchbarkeit, Lebensformen und unsichtbares Design," in *Im Designerpark*, ed. Kai Buchholz, Klaus Wolbert (Darmstadt: Häusser, 2004), pp. 96–105.

6 Courtesy translation of Paola Antonelli, *Design*, Die Sammlung des Museum of Modern Art (Munich, Berlin, London, New York: Prestel, 2003), p. 275.

7 See Josef Straßer, "Utopias in plastic, The euphoria of synthetic materials in the sixties and the early seventies," in Josef Straßer and Renate Ulmer, *Plastics + Design* (Stuttgart: Arnoldsche Art Publishers, 1997), pp. 85; 87.

8 See for example Sylvia Katz, "Plastics in the '80s," in *The Plastics Age*, From Modernity to Post-Modernity, ed. Penny Sparke (London: Victoria & Albert Museum, 1990), pp. 145–151; Oliver Frank, "The changing deformation mechanisms of impact-modified *Plexiglas*," *Röhm Spektrum* 34 (1986): 21–24; Barbara Geppert, "*Plexiglas* F films for display technology," *Röhm Spektrum* 37 (1989): 85–86.

9 See Josef Straßer, "The slow comeback, The eighties and nineties," in Josef Straßer and Renate Ulmer, *Plastics + Design* (Stuttgart: Arnoldsche Art Publishers, 1997), p. 129: "Even designers such as Ron Arad …, who works primarily with metal, began to show an interest in plastic more often. Exemplary for this changed attitude is his book shelf 'Bookworm' of 1993: The success of this object, originally produced of tempered steel, came only with the plastic version, which, as he himself said, was 'lighter, colorful, transparent, simple to attach, and much less expensive.'"

10 Courtesy translation of Volker Albus and Christian Borngräber, *Design-Bilanz*, Neues deutsches Design der 80er Jahre in Objekten, Bildern, Daten und Texten (Cologne: DuMont, 1992), p. 50.

Optische Eigenschaften

Acrylglas besitzt eine Reihe optischer Qualitäten, die es als Material für Brillengläser, Linsen, Lupen, Prismen, Displays, Endoskope und in der Beleuchtungstechnik prädisponieren. Seine Lichtdurchlässigkeit liegt mit 92 % sogar über derjenigen von gewöhnlichem Fensterglas – selbst ein 6 m dicker PMMA-Block würde noch 50 % des einfallenden Lichts durchlassen. Da sich Acrylglas bei erhöhten Temperaturen etwa zehnfach stärker ausdehnt als Silikatglas, sind seinen Verwendungsmöglichkeiten in der Präzisionsoptik Grenzen gesetzt. Die Verbindung aus freier Formbarkeit und hoher Transparenz favorisiert es dagegen für den Messebau und für die Herstellung durchsichtiger Modelle. Strahlt man über die Kante einer farblosen PMMA-Scheibe Licht ein, so wird es innerhalb der Platte nahezu vollständig weitergeleitet. Dabei sind die Absorptionsverluste unter idealen Bedingungen niedriger als bei allen anderen durchsichtigen Stoffen. Dies macht Acrylglas zu einem idealen Lichtleiter, einem Material, das Licht über längere Distanzen an beliebige, unter Umständen auch schwer zugängliche Orte umlenken kann. Solche Lichtleiter sind nicht nur als Raumbeleuchtungen geeignet, sondern finden vor allem auch in der Hintergrundbeleuchtung von TFT-LCD Bildschirmen sowie für Kontrollanzeigen im Auto, beleuchtete medizinische Instrumente, Werbedisplays und optische Druckgeräte Anwendung. Die guten optischen Eigenschaften – zusammen mit Witterungsbeständigkeit, Farbstabilität und hoher Brillanz – sichern PMMA-Formmassen zudem eine Vorrangstellung bei der Produktion von Fahrzeugrückleuchten.

Optical Properties

Acrylic has a number of optical merits that make it the material of choice for spectacle glasses, lenses, magnifying glasses, prisms, displays, endoscopes and applications in lighting technology. Its light transmission of 92 % is even higher than that of conventional window glass. Even a six meter-thick block of PMMA would still let in 50 % of incident light. Since acrylic expands about ten times more than silicate glass at high temperatures, there are limits to its use in precision optics. On the other hand, its combination of free formability and high transparency favor its use for tradeshow booth construction and for building transparent models. Almost 100 % of the light fed into the edge of a clear sheet of PMMA is distributed within the sheet. Under ideal conditions, the absorption losses are lower than those of all other transparent materials. This makes acrylic the ideal lightguide, a material that can propagate light for longer distances to any desired sites, even those that are difficult to access. Beside room lighting, such lightguides are used in backlight modules for TFT-LCD flat-panel displays and for control lamps in cars, illuminated medical instruments, advertising displays and optical printing equipment. Combined with weather resistance, color stability and a high degree of brilliance, the good optical properties of PMMA molding compounds also give them the edge when it comes to manufacturing taillight clusters.

Cat. 77
Stuhl „Teodora", 1986
"Teodora" chair, 1986
Entwurf | Design: Ettore Sottsass

Sessel „Miss Blanche", 1988
Armchair "Miss Blanche," 1988
Entwurf | Design: Shiro Kuramata

Cat. 78
Raumteiler "Fish 'n Chips", 1988
Partition "Fish 'n Chips," 1988
Entwurf | Design: Ad Us Berlin (= Manuel Pfahl, Bettina Wiegandt)

Cat. 76
Experimenteller Stuhl (Entwicklungsmodell), 1982
Experimental chair (development model), 1982
Entwurf | Design: Verner Panton

Bunt und flexibel
Hightech-Werkstoff in der globalisierten Warenwelt

Colorful and Flexible
High Tech Plastic in the Globalized Material World

Kim Seidel, blondes Luxuspüppchen aus der Telenovela „Verliebt in Berlin", heiratet in Folge 518 den schönen Paolo, einen fiesen Spross des italienischen Lederfashion-Clans Amendola. Es ist keine Liebesheirat. Zumal die verwöhnte Fabrikantentochter kurz zuvor erfahren muss, dass ihr zukünftiger Ehemann es nur darauf abgesehen hat, größeren Einfluss im Modehaus Kerima zu gewinnen. Entsprechend unterkühlt gestaltet sich die Trauungszeremonie vor einer Kulisse aus kristallklarem Polymethylmethacrylat. Man fühlt sich ein wenig an den Märchenzauber von Acrylglas-Objekten der späten 30er Jahre erinnert. Allerdings haben hier weniger Schneewittchens gläserner Sarg oder die Ballschuhe von Aschenputtel Pate gestanden, eher der frostige Eispalast aus Hans Christian Andersens „Schneekönigin". So fügt sich das glamouröse Hochzeitsambiente zum Schluss doch noch in unsere von Geld- und Machthunger beherrschte Gegenwart.

Abgesehen von den seichten Schauern des Boulevards, bildet klares Acrylglasdesign heute jedoch die Ausnahme: Seit den 90er Jahren setzen renommierte Entwerfer, die sich für das Material interessieren, auf Farbigkeit. Über Jahr-

Ottmar Hörl: Beleuchtetes Euro-Zeichen aus *Plexiglas*, Europäische Zentralbank Frankfurt am Main, 2002
Ottmar Hörl: Illuminated euro sign made of *Plexiglas*, European Central Bank Frankfurt am Main, 2002

In episode 518 of the German TV series "Verliebt in Berlin" ("In Love in Berlin"), blond bimbo Kim Seidel marries pretty boy Paolo, the unsavory scion of the Italian fashion dynasty Amendola. This union is anything but a love match, especially as Kim, the spoilt-brat daughter of a factory owner, learns shortly before the wedding that her husband-to-be only wants to gain more clout in couture house Kerima. The wedding ceremony takes place in a correspondingly chilly atmosphere with a set design of crystal-clear polymethyl methacrylate, a throwback to the fairytale flair of acrylic objects in the late 1930s. Here, however, we are reminded less of Snow White's glass coffin or Cinderella's glass slippers than of the frosty ice palace in Hans Christian Andersen's "Snow Queen." In this way, the glamorous wedding ambience finally fits back into the power-hungry, money-minded present.

But apart from the stereotype shudders of trivial teletainment, clear acrylic design is nowadays the exception. Since the 1990s, famous designers interested in the material have opted for color. The decades of experience with a variety of colorants now make it possible to manufacture PMMA in almost any desired hue.

This trend is apparent in Philippe Starck's multifunctional coffee table-cum-stool "La Bohème" or Maarten van Severen's chaise longue "LCP." Starck's design is available in three different shapes and five different colors: crystal-clear,

zehnte hinweg gesammelte Erfahrungen mit den unterschiedlichsten Pigmenten gestatten es mittlerweile, PMMA in praktisch jeder beliebigen Farbnuance herzustellen.

Deutlich ablesbar ist der Trend an Philippe Starcks multifunktional verwendbarem Beistelltisch-Hocker „La Bohème" oder an Maarten van Severens Chaiselongue „LCP".

Starcks Entwurf existiert in drei Form- und je fünf Farbvarianten: Glasklar, Gelb, Flaschengrün, Veilchen und Rot. Damit lässt sich das Objekt mühelos in verschiedenste Interieurs einpassen. Im Sinne geschmackvoller Gestaltung ein entscheidender Fortschritt, denn das Zeitalter industrieller Massenfertigung machte es dem Menschen bisher schwer, die Einrichtungselemente seines Wohnraums farblich aufeinander abzustimmen. Ein Blick in die Wohnstuben unserer Gesellschaft legt zwar nahe, dass vielen die Farbenharmonie ihrer Privatsphäre gleichgültig zu sein

yellow, bottle green, violet and red, which enable the object to fit smoothly into various decors. This is a crucial advantage in terms of tasteful decoration, because the age of industrial mass production makes it hard for people to color-match the individual elements of their room furnishings. Although a brief look at today's living rooms might suggest that many people care little about harmonious colors in their private abodes[1], this impression should not blind us to the major, albeit unconscious influence that aesthetic atmospheres have on our well-being.[2]

Hochzeitsszene aus der Telenovela „Verliebt in Berlin", 2007
Wedding scene in German TV series "Verliebt in Berlin", 2007

Möbel aus *Plexiglas*, 1990
Plexiglas furniture, 1990
Entwurf | Design: Sergio Longoni

scheint¹; ein solcher Befund darf jedoch nicht darüber hinwegtäuschen, dass ästhetische Atmosphären unsere Befindlichkeit unbewusst, aber maßgeblich beeinflussen.² Mit Kalkül eingesetzt, dienen erlesen ausgestattete Interieurs oft der Selbstinszenierung, wobei – wie Gernot Böhme feststellt – aristokratische Formen der Machtdemonstration vielfach das Vorbild abgeben: „Marmor und Edelstahl noch in den U-Bahnhöfen, Gold, Silber, edle Holztäfelungen in den Restaurants, Kaufhäusern, Flughäfen. Dazu die Farbenpracht der Blumen, die Eleganz der Stoffe, über allem das Geflimmer und Gleißen der Spotlights, der Halogenlämpchen, die zwischen Spiegeln und Scheiben und marmornen Fußböden auf und ab, hin und her hüpfen. Das Urbild dieser Inszenierungen ist unschwer zu erraten. Es ist das fürstliche Schloß, das mit dem Glanz seiner Lichter dem späten, aber immer noch steigerungsfähigen Kapitalismus seine Ästhetik geliehen hat."³ Möglicherweise will Starck mit „La Bohème" ähnliche Repräsentationsbedürfnisse stillen, greift er doch bei den Silhouetten seiner Hocker, die trotz des edel glänzenden Materials wetterfest und damit auch im Outdoor-Bereich verwendbar sind, bewusst auf die Gestalt antiker Amphoren zurück.

Ciutat de les Arts i les Ciències in Valencia mit Verglasungen aus *Plexiglas* im oberen Gebäudeabschnitt, 2002
Ciutat de les Arts i les Ciències in Valencia with *Plexiglas* glazing in upper section of building, 2002
Entwurf | Design: Santiago Calatrava, Félix Candela

When strategically chosen, classy interior design often serves as a stage for self-presentation, and as Gernot Böhme astutely observes, aristocratic forms of power play often act as role models: "Marble and stainless steel are still used in subway stations, gold, silver and noble timber paneling in restaurants, department stores and airports. Added to these are profusions of flowers and elegant fabrics, all bathed in the glittering and twinkling of spotlights and halogen lamps that pop up between mirrors and panels and marble floors. It is not hard to guess where this type of presentation took its cue from – the royal castle, which has lent its aesthetics and incandescent splendor to the late capitalist era, still capable of going one step further."³ Perhaps Starck wants to satisfy a similar hunger for prestigious presentation with "La Bohème" –

> „Die Thermoskanne Basic gilt als das erste und erfolgreichste technische Haushaltsprodukt aus transparentem Material. Seit knapp 17 Jahren produziert, inspirierte sie Objekte wie den iMac und förderte insgesamt die Wertschätzung von PMMA im Design."
>
> Ross Lovegrove

Maarten van Severens LCP (= Low Chair Plastic) setzt dagegen das ästhetische Repertoire der klassischen Moderne fort. Die in fluoreszierendem Gelb und Pink sowie in Glasklar und Himmelblau lieferbare Chaiselongue ist im Wesentlichen aus einer einzigen, schwungvoll gekrümmten PMMA-Platte gefertigt und eindeutig dem neuen Minimalismus zuzurechnen – einer bewussten Gegenreaktion auf die Formexzesse postmoderner Gestalter. Ähnlich wie bei den rationalistischen Entwürfen des Bauhauses und später der Hochschule für Gestaltung Ulm gehen fortschrittliche Technik und Design bei van Severen eine Symbiose ein, um der technischen Zivilisation sinnliche Strahlkraft zu verleihen.

Unter technologischen Aspekten besonders hervorzuheben sind Entwürfe wie Patrick Norguets Acrylglas-Stuhl „Rainbow", Barbara Crettaz' Sonnenliege „Rainbow 1006" und François Azambourgs Leuchte „Brindille luminaire". Während der Fertigung von Norguets Stuhl werden transparente PMMA-Streifen in verschiedenen Farben mittels Ultraschall zusammengefügt – eine technische Innovation, die dem Acrylglas eine bisher unbekannte Ausstrahlung beschert: Der hoch lichtdurchlässige Werkstoff entfaltet hier ein dekoratives Farbenspiel, das je nach Beleuchtungssituation immer wieder neue, unerwartete Wandlungen erfährt. Auch die Sonnenliege von Barbara Crettaz verdankt ihren Reiz der Verwendung verschiedenfarbiger PMMA-Streifen. Allerdings setzt die Designerin Material mit satinierten Oberflächen ein, was ihrem Entwurf in diffusem Licht eine erdige Materialität verleiht, die erst bei starker Lichtstrahlung in Leichtigkeit umschlägt. Handwerklicher Tradition entlehnt, beruht die Flechtoptik der Liege auf einer eigens entwickelten Verarbeitungsmethode: Die losen Acrylglasstreifen werden erwärmt, mittels Schablonen in Form gebracht und in einer besonderen Stecktechnik miteinander verflochten. François Azambourgs Leuchte

the silhouette of his stool, which is weather-resistant and thus suitable for outdoor use despite the noble gloss of the material, consciously reflects the shape of antique amphorae.

By contrast, Maarten van Severen's LCP (= Low Chair Plastic) resumes the aesthetic repertoire of classical modernism. The chaise longue available in fluorescent yellow and pink as well as crystal-clear and sky blue basically consists of a single, dynamically curved sheet of PMMA and is clearly attributable to present-day minimalism, a conscious counter-reaction to the curlicues of post-modern designers. As with the rationalistic designs of Bauhaus and later of the Ulm School for Design, in van Severen's work, design enters into a symbiosis with progressive technology to infuse technical civilization with sensual appeal.

Designs worthy of special mention for their technological aspects include Patrick Norguet's acrylic chair "Rainbow", Barbara Crettaz's sun lounger "Rainbow 1006" and François Azambourg's lamp "Brindille luminaire". Norguet's chair is fabricated by ultrasonic welding of differently colored transparent PMMA strips, a technical innovation that gives an unprecedented glow to the acrylic. Here, the highly light transmitting material displays a decorative play of colors that continuously changes in unexpected ways depending on the lighting conditions. The sun lounger by Barbara Crettaz also owes its attractive appearance to the use of differently colored strips of PMMA. Crettaz, however, uses material with matte satin surfaces that give her design an earthy materialism when viewed in diffuse light. Only when brightly illuminated, does this impression switch to one of lightness. True to the tradition of craftsmanship, the woven appearance of the lounger is based on a novel fabrication method developed by Crettaz herself. The separate strips of acrylic are heated, shaped using templates and interlaced by means of a special

Haifisch-Tunnel aus *Plexiglas*, Loro Parque
Teneriffa, 2002
Shark tunnel made of *Plexiglas*, Loro Parque
Teneriffa, 2002

Kunsthaus Graz mit Außenhaut aus blauem *Plexiglas*, 2003
Kunsthaus Graz with outer skin made of blue *Plexiglas*, 2003
Entwurf | Design: Peter Cook, Colin Fournier

„Brindille luminaire" bedient sich zwar nicht der unbegrenzten Einfärbungsmöglichkeiten des hochwertigen Kunststoffs, macht sich aber ebenfalls in innovativer Weise die besonderen optischen Eigenschaften von PMMA zu Nutze, nämlich seine Fähigkeit der nahezu vollständigen Lichtdurchleitung: Mit ihrem filigranen Geäst farbloser Acrylglasröhrchen, deren Enden im eingeschalteten Zustand leuchten, lassen sich Innenräume in ein dezentes, stimmungsvolles Licht tauchen.

Die Thermoskanne „Basic" von Ross Lovegrove verschafft PMMA sogar den Durchbruch im Industriedesign. Der britische Gestalter, dessen Arbeiten nach eigenen Angaben auf seinem intuitiven Gespür für Werkstoffe basieren und der sich besonders von Kunststoffen angesprochen fühlt, richtet seine Entwürfe oft an der chemischen Struktur sowie am Aufbau und an der Funktionsweise lebender Organismen aus.[4] Die wesentlichen Aspekte seiner Thermoskanne erläutert er selbst wie folgt: „Die Thermoskanne Basic, erstmals 1987 angedacht, erkundete das Verhältnis zwischen dem Innen und Außen eines Produkts. In ihrer Transparenz demonstriert sie die ehrliche Materialverwendung und offenbart damit ihren Aufbau ohne Blend-

insertion technique. Although François Azambourg's lamp "Brindille luminaire" does not exploit the unlimited colorability of the high-quality plastic, it makes similar innovative use of the special optical properties of PMMA, i. e. its ability to guide almost 100 % of light. When the lamp is switched on, its delicate tracery of clear acrylic twigs with glowing tips bathes interiors in subtle atmospheric light.

Ross Lovegrove's "Basic" thermos flask was even instrumental to PMMA's breakthrough in industrial design. The British designer whose work is based on his self-professed intuitive feel for materials, is particularly attracted by plastics. His designs are often based on the chemical structure, composition and function of living organisms.[4] Lovegrove explains the salient features of his thermos flask as follows: "The Basic Thermos Flask,

werk und Effekthascherei. Ihr optisches Erscheinungsbild vermittelt den Eindruck von Leichtigkeit und beruht auf einer klaren Geometrie, um Form, Funktion und Material harmonisch in Beziehung zueinander zu setzen. Sie ist dafür konzipiert, auseinandergenommen zu werden, und zwar so, dass sie im zusammengesetzten Zustand, obwohl die Verbindungsstücke sichtbar bleiben, keinerlei Kompromisse hinsichtlich ihrer gestalterischen Geschlossenheit eingeht. Eine solche Formgebung, die nur mit dem verwendeten Material und präziser Verarbeitung zu erzielen ist, lässt Objekte entstehen, deren Wert über das rein Materielle und Funktionale hinausreicht."[5]

Nach dem großen Erfolg des Münchner Olympiastadions feiert PLEXIGLAS® im September 2003 einen weiteren architekturhistorischen Etappensieg: die Eröffnung des neuen Kunsthauses in Graz, das die Architekten Peter Cook und Colin Fournier liebevoll „Friendly Alien" taufen.[6] Mit seiner Außenhaut aus transparent blau eingefärbten, computergeformten PMMA-Platten wirkt es wie eine Mischung aus Marsmensch und Walfisch. Obwohl eigent-

first conceived in 1987, explored the relationship between the inside and outside of a product, conveying in its transparency an honesty of material use, revealing its true composition without effect or pretence. Its optical nature reduces its mass whilst retaining an essential geometry to provide a harmony between its form, function and material. It has been designed for disassembly and in such way that the assembled product is not compromised by losing any of its inherent completeness even if the connection details between components remain apparent. Such composition, made possible by material application and precision manufacture, creates products of a higher value than simply their material or functional content." [5]

Following the huge success of Munich's Olympic Stadium, PLEXIGLAS® celebrated another milestone in architectural history in September 2003 with the opening of the new Kunsthaus museum in Graz, affectionately named "Friendly Alien" by its architects Peter Cook and Colin Fournier.[6] With its outer skin of transparent blue, computer-designed

lich ein Fremdkörper in der historisch bebauten Innenstadt, fügt sich der knuddelig gerundete Bau samt seiner pockenartigen Oberlichter friedfertig in die Stadtlandschaft ein. Der Clou: Die unter dem Acrylglasmantel verborgenen 930 Leuchtstoffröhren verwandeln die Gebäudehülle bei Bedarf in einen gigantischen Bildschirm, auf dem sich Texte oder Filmsequenzen vorführen lassen.[7] Hier findet das mittlerweile zum Event mutierte Kulturleben ideale Bedingungen seiner Selbstdarstellung.

Damit ist der „Friendly Alien" gleichzeitig ein Spiegelbild unserer globalisierten Konsumwelt, die menschliches Feingefühl und soziale Ungleichheit hinter den verlockenden Oberflächen kurzfristiger Fun-Versprechen zu nivellieren versucht.[8] Alles scheint sich nur noch um das große Geld, verkaufsförderndes Styling und den seichten Freizeitspaß zu drehen – ein Phänomen, das man mit Böhme als Phase der ästhetischen Ökonomie beschreiben kann.[9]

Von dieser Tendenz wird seit den 90er Jahren auch der Werkstoff Acrylglas erfasst. Im Automobilbau tragen neue Designauffassungen und vor allem eine stärkere Plastizi-

PMMA sheets, it looks like a cross between a whale and a Martian. Despite being a foreign body in the historic center of the city, this roly-poly building with its pockmark skylights fits peaceably into the cityscape. Its special feature are the 930 neon tubes under the acrylic skin, which transform it as required into a gigantic screen on which texts or movie sequences can be projected.[7] These are ideal conditions for the new predilection of staging cultural life as an event in its own right.

"Friendly Alien" thus holds a mirror to our globalized consumer world that attempts to shut out human sensitivity and social injustice behind the tantalizing images of fleeting fun.[8] Everything appears to revolve around big money, promotional styling and shallow fun and games – a phenomenon that can be described in agreement with Böhme as a phase of aesthetic economy.[9]

Acrylic has also been caught up in this tendency since the 1990s. In automotive construction, new concepts of design and above all, car bodies with more scope for

"Widely considered as the first and most successful transparent domestic product created, the Basic Thermos Flask has been in constant production for almost 17 years, inspiring products such as the iMac and helping to elevate the perception of PMMA generally in design."

Ross Lovegrove

tät der Fahrzeugkarosserien dazu bei, dass Scheinwerfer und Heckleuchten jetzt individueller geformt und größer dimensioniert werden. So verwandeln sich die bisherigen funktionalen Elemente der Fahrzeugbeleuchtung in geschickt inszenierte Erkennungszeichen der verschiedenen Automarken und der einzelnen PKW-Typen. Die Wechselwirkung von Marketing und technischem Fortschritt, etwa der computergestützten Reflektorenberechnung, haben diese Strömung rasant beschleunigt. Im Novemberheft des Jahres 2002 erläutert die Zeitschrift „Plexipoint" zudem, wie sich der Trend zur Eventkultur im Bereich öffentlicher Großaquarien ausbreitet. Unter der Überschrift „Schmusekurs im Haifischbecken" erklärt der entsprechende Beitrag neue Verfahren,

sculptural forms, have meant that headlamps and taillights are now more individually shaped and made larger. Previously functional elements of vehicle lighting are being transformed into cleverly presented distinguishing features of the various makes and models of cars. The interaction between marketing wishes and technical progress, such as computer-assisted reflector calculation, have dramatically accelerated this tendency. The November 2002 issue of the "Plexipoint" magazine also explains how the trend toward 'event culture' is catching on at large public aquariums. The article entitled "Cozying up to the sharks" outlines new processes for manufacturing components of long tunnel-shaped public aquariums made of *Plexiglas*. Visitors to these are surrounded by

Geldkoffer der ARD-Fernsehlotterie aus *Plexiglas*, 2004
Plexiglas suitcase full of money in ARD TV lottery, 2004

mit denen sich Bauteile für lange, tunnelförmige Schau-Aquarien aus *Plexiglas* erzeugen lassen, Aquarien, vor denen der Besucher – gleichsam vom Wasser umschlossen – Haie und andere Fische hautnah erleben kann. In diesem Zusammenhang wird der Freizeitforscher Horst W. Opaschowski mit der Bemerkung zitiert: „Heute und in Zukunft sorgt eine mächtige Freizeitindustrie für Glücksversprechen, Traumwelten und künstliche Paradiese."[10] Die Oktoberausgabe 2004 derselben Zeitschrift stellt ein weiteres interessantes Objekt aus *Plexiglas* vor: den Koffer der ARD-Show „Einfach Millionär werden". Hier gewährt der glasklare Kunststoff freie Sicht auf zweitausend 500-Euro-Scheine – eine Million zum Greifen nahe. In diesem Objekt der Begierde materialisieren sich gleichsam die Wunsch- und Wertvorstellungen unserer neoliberalen

water on all sides and can experience sharks and other fish close up. In this context, futurist and social scientist Horst W. Opaschowski is quoted as saying: "Today's powerful leisure industry promises happiness, dream worlds and artificial Gardens of Eden, and that will also be the case in the future."[10] The same magazine presents another interesting object made of *Plexiglas* in its October 2004 issue: the suitcase used in "Einfach Millionär werden" ("Make a Million the Easy Way") on Germany's ARD TV channel. The crystal-clear plastic offers a perfect view of two thousand 500-euro bills – a million euros only a hand's grasp away. This object of desire embodies the wishes and values of our neoliberal world. The material itself is of course neutral, and the many new prospective applications it enables thanks to continuous technological progress are remarkable. If we handle them responsibly, they have enormous potential to enrich human life in a variety of ways.[11]

Welt. Der Werkstoff selbst ist dabei natürlich wertneutral und die vielen neuen Anwendungsmöglichkeiten, die er dank kontinuierlichen technologischen Fortschritts ermöglicht, sind bemerkenswert. Wenn wir verantwortungsvoll mit ihnen umgehen, können sie das menschliche Leben enorm bereichern.[11]

Anmerkungen

1 Vgl. dazu Kai Buchholz: Die Realität des Einrichtens und Wohnens. In: Im Designerpark. Hg. K. Buchholz, K. Wolbert. Darmstadt 2004. S. 690–705.

2 Vgl. Gernot Böhme: Atmosphäre. Essays zur neuen Ästhetik. Frankfurt a. M. 1995.

3 Ebd., S. 51.

4 Vgl. Ross Lovegrove: Supernatural. The Work of Ross Lovegrove. London, New York 2004. S. 31/32.

5 Übersetzt nach ebd., S. 32/33.

6 Zu diesem Gebäude vgl. A Friendly Alien. Ein Kunsthaus für Graz. Hg. D. Bogner. Ostfildern-Ruit 2004.

7 Vergleichbare großflächige Lichteffekte gestattet auch die aus Folienkissen aufgebaute Umhüllung der Münchner *Allianz*-Arena. Das vom Architekturbüro Herzog & de Meuron entworfene Fußballstadion erstrahlt nach Belieben in den Vereinsfarben des FC Bayern München oder des TSV 1860 und lässt sich in seiner Lichtintensität der Dramatik des jeweiligen Spielverlaufs anpassen. Dabei erfolgt die Einfärbung mittels Diffusor-Abdeckungen in rotem, blauem und klarem *Plexiglas*. Vgl. Anonymus: Eine Arena der Sinne. Dreifarbige Lichtspiele zaubern tolle Effekte auf die größte Membranhülle der Welt an der Münchener *Allianz*-Arena. In: Licht. 57 (2005). S. 614–619.

8 Vgl. Kai Buchholz und Minu Hemmati: Vom Nutzen der Geisteswissenschaften. In: Universitas. 35 (1998). S. 1074–1086; Kai Buchholz: ›L'homme est responsable de ce qu'il est.‹ Bemerkungen zum anthropologischen Fundament der Politik. In: Wege zur Vernunft. Hg. K. Buchholz, S. Rahman, I. Weber. Frankfurt a. M., New York 1999. S. 73–87; Ders.: Der blinde und der sehende Amor. Über Liebe, Selbstkultivierung und Erkenntnis. In: Praxis der Philosophie – Gernot Böhme zum 70. Geburtstag (= 3. Jahrbuch für Lebensphilosophie). Hg. D. Croome, U. Gahlings, R. J. Koziljanič. München 2007. S. 197–206.

9 Vgl. Gernot Böhme: Atmosphäre. Essays zur neuen Ästhetik. Frankfurt a. M. 1995. S. 63: „*Ästhetische Ökonomie* bezeichnet eine bestimmte Phase des entwickelten Kapitalismus. Diese kann in zweierlei Weise charakterisiert werden: 1. Ein Großteil der gesamtgesellschaftlichen Arbeit ist ästhetische Arbeit oder Inszenierungsarbeit. Unter ästhetischer Arbeit ist allgemein die Produktion von Aussehen und Atmosphären zu verstehen, d. h. alle die Tätigkeiten, in denen es nicht darum geht, Produkte herzustellen oder Prozesse in Gang zu halten, sondern den Dingen und Menschen ein Aussehen zu geben und sie ins rechte Licht zu rücken. Zu den ästhetischen Arbeitern gehören natürlich die Designer, dann aber auch die Kosmetiker, Bühnenbildner, Innenarchitekten, Werbe- und Modeleute und viele andere. ... 2. Die produzierten Werte sind in dieser Phase des entwickelten Kapitalismus in wachsendem Maße ästhetische Werte. Der Werttyp *ästhetischer Wert* tritt als besonderer überhaupt erst in dieser Phase heraus, obgleich es ihn *mitfolgend* natürlich schon immer gegeben hat. Karl Marx unterscheidet an den Waren den Gebrauchswert vom Tauschwert. Diese Zweiteilung erweist sich inzwischen als unzureichend." Vgl. in diesem Zusammenhang auch Ronald Hitzler: Postmoderne Erlebnisstätten als Tourismus-Alternative des 21. Jahrhunderts. In: Im Designerpark. Hg. K. Buchholz, K. Wolbert. Darmstadt 2004. S. 624–627; Horst W. Opaschowski: Arbeit und Freizeit. In: Im Designerpark. Hg. K. Buchholz, K. Wolbert. Darmstadt 2004. S. 504–509.

10 Vgl. Nicole Galliwoda: Schmusekurs im Haifischbecken. Unterwasseraquarien: Der Trend geht zum Event. In: Plexipoint. 2002, Heft 8. S. 9.

11 Vgl. dazu Jürgen Mittelstraß: Leonardo-Welt. Über Wissenschaft, Forschung und Verantwortung. Frankfurt a. M. 1992.

Notes

1 See Kai Buchholz, "Die Realität des Einrichtens und Wohnens," in *Im Designerpark*, ed. Kai Buchholz, Klaus Wolbert (Darmstadt: Häusser, 2004), pp. 690–705.

2 See Gernot Böhme, *Atmosphäre*, Essays zur neuen Ästhetik (Frankfurt a. M.: Suhrkamp, 1995).

3 Courtesy translation of ibid, p. 51.

4 See Ross Lovegrove, *Supernatural*, The Work of Ross Lovegrove (London, New York: Phaidon, 2004), pp. 31–32.

5 Ibid, pp. 32–33.

6 On this building, see *A Friendly Alien*, Ein Kunsthaus für Graz, ed. Dieter Bogner (Ostfildern-Ruit: Hatje Cantz, 2004).

7 The outer shell of Munich's *Allianz* Arena, consisting of film cushions, enables similar large-area lighting effects. The soccer stadium designed by architects Herzog & de Meuron can be lit with the colors of the FC Bayern München or TSV 1860 soccer clubs, and the lighting intensity can be adjusted to the level of suspense at a given stage of the game. The coloring is controlled via diffusor lenses in red, blue and clear *Plexiglas*. See anonymous, "Eine Arena der Sinne, Dreifarbige Lichtspiele zaubern tolle Effekte auf die größte Membranhülle der Welt an der Münchener *Allianz*-Arena," *Licht* 57 (2005): 614–619.

8 See Kai Buchholz and Minu Hemmati, "Vom Nutzen der Geisteswissenschaften," *Universitas* 35 (1998): 1074–1086; Kai Buchholz, "'L'homme est responsable de ce qu'il est,' Bemerkungen zum anthropologischen Fundament der Politik," in *Wege zur Vernunft*, ed. Kai Buchholz, Shahid Rahman, Ingrid Weber (Frankfurt a. M., New York: Campus, 1999), pp. 73–87; "Der blinde und der sehende Amor, Über Liebe, Selbstkultivierung und Erkenntnis," in *Praxis der Philosophie – Gernot Böhme zum 70. Geburtstag* (= 3. Jahrbuch für Lebensphilosophie), ed. Doris Croome, Ute Gahlings, Robert J. Koziljanič (Munich: Albunea, 2007), pp. 197–206.

9 See Gernot Böhme, *Atmosphäre*, Essays zur neuen Ästhetik (Frankfurt a. M.: Suhrkamp, 1995), p. 63: "*Aesthetic economy* designates a certain phase of developed capitalism. This phase can be characterized in two ways: 1. A large part of the overall work performed by a society is aesthetic or performance work. By aesthetic work, what is meant is the general production of appearance and atmosphere, i. e. all those activities that do not have to do with manufacturing products or maintaining processes, but with giving humans and things an appearance and putting them in the right light. Aesthetic workers of course include designers, but also beauticians, set designers, interior designers, advertising and fashion professionals and many others. ... 2. In this phase of developed capitalism, the produced values are increasingly aesthetic values. The *aesthetic value* type stands out as such particularly during this phase, although it has of course always existed *among others*. Karl Marx distinguishes between the use value and the exchange value of a commodity. Meanwhile, this division into two categories proves inadequate." (Courtesy translation from German). In this context, see also Ronald Hitzler, "Postmoderne Erlebnisstätten als Tourismus-Alternative des 21. Jahrhunderts," in *Im Designerpark*, ed. Kai Buchholz, Klaus Wolbert (Darmstadt: Häusser, 2004), pp. 624–627; Horst W. Opaschowski, "Arbeit und Freizeit," in *Im Designerpark*, ed. Kai Buchholz, Klaus Wolbert (Darmstadt: Häusser, 2004), pp. 504–509.

10 See Nicole Galliwoda, "Cozying up to the sharks, Underwater aquariums offer amazing aquatainment," *Plexipoint* 2002, Issue 8: 8.

11 See Jürgen Mittelstraß, *Leonardo-Welt*, Über Wissenschaft, Forschung und Verantwortung (Frankfurt a. M.: Suhrkamp, 1992).

Witterungsbeständigkeit

Acrylglas findet breite Anwendung bei der Herstellung von Leuchtreklamen, Fensterrahmen, Überdachungen, Gewächshäusern, Solarmodulen, Karosserieanbauteilen und Flugzeugfenstern. Alle diese Produkte stellen hohe Anforderungen an die Witterungsbeständigkeit: Die aus PMMA gefertigten Kabinenfenster eines Düsenjets müssen tropischem Regenwetter genauso standhalten wie einem Sandsturm in der Sahara oder der klirrenden Kälte arktischer Gebiete. Natürlich weist praktisch jedes Material nach Freibewitterung Ermüdungs- und Abnutzungserscheinungen auf. Die im Sonnenlicht enthaltene UV-Strahlung kann auch bei PMMA zum Bruch einzelner Ketten führen, dennoch besitzt Acrylglas im Vergleich zu anderen Werkstoffen eine besonders hohe Witterungsbeständigkeit. Ein Langzeitversuch unter mitteleuropäischen Klimabedingungen, der sich über 25 Jahre erstreckte, hat ergeben, dass die →Zugfestigkeit von PMMA nach diesem Zeitraum immer noch zwischen 75 und 65 N/mm^2 liegt, die Bruchsicherheit durch Bewitterung also nicht beeinflusst wird. Die Untersuchung der →Schlagzähigkeit lieferte vergleichbare Ergebnisse, wobei die Werte hier sogar mit den an unbewittertem Material gemessenen identisch waren. Als besonders stabil erwiesen sich die optischen Eigenschaften: Trotz intensiver Bewitterung waren selbst nach 25 Jahren keine wesentlichen Veränderungen des Reflexionsverhaltens, der Lichtdurchlässigkeit und der Lichtabsorption festzustellen. Acrylglas bewahrt somit über Jahrzehnte seine klare Durchsichtigkeit und vergilbt nicht.

Weather Resistance

Acrylic is widely used for manufacturing illuminated signs, window frames, roofing, greenhouses, solar modules, add-on automotive body components and aircraft cabin windows. All these products make high demands on weather resistance. In cabin windows, PMMA has to withstand tropical downpours, Saharan sandstorms and the icy cold of Arctic regions. Obviously, all materials show signs of wear and fatigue after outdoor exposure. The UV portion of solar radiation can also cause individual chain fission in PMMA, but in comparison with other materials, acrylic offers particularly high weather resistance. After a 25-year test under the climatic conditions of Central Europe, the →tensile strength of PMMA was still between 75 and 65 N/mm^2, which signifies that its resistance to breakage is not influenced by weathering. The examination of →impact strength provided similar results, with values that were in fact identical to those of non-weathered material. The optical properties proved to be especially stable. Despite intensive weathering, no essential changes in reflection, light transmittance and light absorption were established after 25 years. That means acrylic retains its clarity and transparency for decades and shows no yellowing.

Cat. 87
Chaiselongue „LCP", 2000
Chaise longue "LCP," 2000
Entwurf | Design: Maarten van Severen

Cat. 93
Containerkubus „Optic", 2006
Container cube "Optic," 2006
Entwurf | Design: Patrick Jouin

Cat. 88
Stuhl „Rainbow", 2000
Chair "Rainbow," 2000
Entwurf | Design: Patrick Norguet

Cat. 89
Hocker/Tischchen „La Bohème 1–3", 2000/01
Stool-cum-coffee table "La Bohème 1–3," 2000/01
Entwurf | Design: Philippe Starck

Cat. 81
Käsereibe „Parmenide", 1994
Cheese grater "Parmenide," 1994
Entwurf | Design: Alejandro Ruiz

Cat. 91
Sonnenliege „Rainbow" Modell 1006, 2005
Sun lounger "Rainbow" model 1006, 2005
Entwurf | Design: Barbara Crettaz

Cat. 92
Leuchte „Brindille luminaire", 2006
Lamp "Brindille luminaire," 2006
Entwurf | Design: François Azambourg

Cat. 80
Thermoskanne „Basic", 1991
"Basic" thermos flask, 1991
Entwurf | Design: Julian Brown, Ross Lovegrove

Glossar
Glossary

Atom Atome sind die elementaren Bausteine der Materie. Sie bestehen unter anderem aus einem oder mehreren positiv geladenen Kernteilchen (Protonen) und jeweils ebenso vielen negativ geladenen Teilchen (Elektronen), die den Kern in unterschiedlichen Orbitalen umgeben.

Druckfestigkeit Die Widerstandsfähigkeit eines Werkstoffs bei der Einwirkung von Druckkräften bezeichnet man als dessen Druckfestigkeit. Angegeben wird die Druckfestigkeit als Verhältnis zwischen einwirkender Drucklast und Querschnittsfläche des untersuchten Probekörpers (Maßeinheit z. B. N/mm^2).

Element Stoffe, die aus unverbundenen, gleichartigen →Atomen bestehen, werden Elemente genannt. Insgesamt sind bisher 118 chemische Elemente bekannt – vom Wasserstoff (H), das nur ein Proton besitzt, bis zum Ununoctium (Uuo) mit 118 Protonen.

Formmasse Thermoplastischer Kunststoff, z. B. in Granulatform, der aufgeschmolzen formgebend weiterverarbeitet wird.

Initiator Stoff, der in Verbindung mit Licht, Strahlung oder Wärme eine chemische Kettenreaktion auslöst.

Kohlenstoff (C) Vierwertiges chemisches →Element, das am Aufbau zahlreicher Natur- und Kunststoffe beteiligt ist. Er weist bei chemischer Reaktion von allen Elementen den größten Variantenreichtum auf. Sein Kern besitzt sechs Protonen. Graphit und Diamant bestehen aus reinem Kohlenstoff in verschiedener Anordnung.

Maßeinheiten
m = Meter (Einheit der Länge)
s = Sekunde (Einheit der Zeit)
g = Gramm (Einheit der Masse)
N = Newton (Einheit der Kraft, 1 N = 1 kg · m/s^2)
J = Joule (Einheit der Energie, 1 J = 1 Nm)

Molekül Moleküle sind zusammengesetzte Bausteine der Materie. Sie entstehen durch die Verbindung von →Atomen im Prozess chemischer Reaktion. Bei diesem Prozess schließen sich einzelne Elektronen aus den äußeren Schichten je zweier Atome zu einem Elektronenpaar in einem gemeinsamen Aufenthaltsbereich (Bindungsorbital) zusammen. Nur diejenigen

Atom Atoms are the basic building blocks of all matter. Among their constituents are one or more positively charged core particles (protons) and an equal number of negatively charged particles (electrons) that orbit the nucleus on different paths.

Bead polymerization →Polymerization during which the →monomer is distributed in relatively large droplets in water or other suitable liquids. This gives rise to a bead-shaped →polymer.

Carbon (C) Quadrivalent chemical →element that enters into the composition of many natural and synthetic materials. It shows the greatest variety of chemical reactions of all elements. Its nucleus consists of six protons. Graphite and diamonds consist of different arrangements of pure carbon.

Compressive strength This describes the resistance of a material to compressive forces. The compressive strength is stated as the ratio between the compressive load and the cross-sectional area of the test specimen (unit of measurement e. g. N/mm^2).

Element Substances that consist of identical free →atoms are termed elements. So far, 118 chemical elements are known to exist, ranging from hydrogen (H), which has only one proton, to ununoctium (Uuo) with 118 protons.

Hydrogen (H) Univalent chemical →element whose core has one proton. Hydrogen is the most common chemical element in the universe but does not occur in its atomic form under normal conditions. On earth, it occurs as molecular hydrogen H_2, a colorless and odorless gas, and is a constituent of water and most organic compounds.

Impact strength This designates the ability of a material to absorb impact energy without breaking. The impact strength is measured as the ratio between the impinging impact energy and the cross-sectional area of the test specimen (unit of measurement e. g. kJ/m^2).

Initiator Substance that causes a chemical chain reaction in combination with light, radiation or heat.

Molding compound Thermoplastic material, e. g. in pellet form, that is melted prior to forming.

Elektronen in der äußeren Schicht eines Atoms, die sich allein in einem Orbital aufhalten, sind in solcher Weise bindungsfähig. Ihre Anzahl ist für ein →Element spezifisch: Wasserstoff, beispielsweise, besitzt ein bindungsfähiges Elektron und wird deshalb als einwertig bezeichnet.

Monomer Reaktionsfähiges Molekül, das sich mit anderen Monomeren zu einer molekularen Kette oder einem molekularen Netz, dem so genannten →Polymer, zusammenschließen kann.

Perlpolymerisation →Polymerisation, bei der das →Monomer in relativ großen Tröpfchen in Wasser oder anderen geeigneten Flüssigkeiten verteilt ist. Dadurch entsteht ein perlförmiges →Polymer.

Polymer Durch die Verbindung von →Monomeren entstandenes Ketten- oder Makromolekül.

Polymerisation Prozess der Verbindung von →Monomeren zu polymeren Molekülketten.

Polymethylmethacrylat (PMMA) Transparenter, hoch lichtdurchlässiger, kratzfester Kunststoff, der in der Umgangssprache „Acrylglas" genannt wird. Je nach Hersteller sind oder waren auch die folgenden Bezeichnungen gebräuchlich: ACRYLITE®, Acryloid, Altuglas, *Crystalite*, DEGLAS®, *Diakon*, Kallodent, *Lucite*, Lumacryl, *Oroglas*, *Perspex*, Piacryl, PLEXIGLAS®, PLEXIGUM®, Shinkolite, Sumipex, *Vedril*, Vitredil.

Sauerstoff (O) Zweiwertiges chemisches →Element, dessen Volumenanteil in der Atemluft etwa 21 % beträgt. Sein Kern besitzt acht Protonen. In seiner atomaren Form findet sich Sauerstoff nur vereinzelt im Vakuum des Weltalls oder in heißen Sternatmosphären. Unter Normalbedingungen tritt reiner Sauerstoff überwiegend als biatomares O_2 oder triatomares O_3 (Ozon) auf.

Schlagzähigkeit Unter der Schlagzähigkeit eines Materials versteht man seine Fähigkeit, Schlagenergie zu absorbieren ohne zu brechen. Gemessen wird die Schlagzähigkeit als Verhältnis der auftreffenden Schlagenergie zur Querschnittsfläche des untersuchten Probekörpers (Maßeinheit z. B. kJ/m^2).

Wasserstoff (H) Einwertiges chemisches →Element, dessen Kern ein Proton besitzt. Wasserstoff ist das häufigste chemische Element des Universums, kommt in seiner atomaren Form unter Normalbedingungen jedoch nicht vor. Auf der Erde liegt er als molekularer Wasserstoff H_2, einem farb- und geruchlosen Gas, vor und ist Bestandteil des Wassers und der meisten organischen Verbindungen.

Zugfestigkeit Die Widerstandsfähigkeit eines Werkstoffs bei der Einwirkung von Zugkräften bezeichnet man als dessen Zugfestigkeit. Angegeben wird die Zugfestigkeit als Verhältnis zwischen einwirkender Zugkraft und Querschnittsfläche des untersuchten Probekörpers (Maßeinheit z. B. N/mm^2).

Molecule Molecules are aggregates of atoms, the building blocks of matter. They are formed by the combination of →atoms during chemical reaction. In this process, individual electrons from the outermost shells of two atoms bind together to form an electron pair that occupies the same bonding orbital. Only electrons in the outermost shell of an atom that occupy their own orbital are capable of forming such bonds. Their number is specific for a given →element. Hydrogen, for instance, has one electron capable of bonding and is therefore termed monovalent.

Monomer Reactible molecule that can combine with other monomers to form a molecular chain or network, a so-called →polymer.

Oxygen (O) Bivalent chemical →element that makes up about 21 % of the air we breathe. Its nucleus has eight protons. In its atomic form, oxygen is only found in isolated areas of the vacuum of space or in the hot atmosphere of stars. Under normal conditions, pure oxygen mainly occurs as biatomic O_2 or triatomic O_3 (ozone).

Polymer A chain molecule or macromolecule formed by the combination of →monomers.

Polymerization Process in which →monomers combine to form polymeric molecular chains.

Polymethyl methacrylate (PMMA) Transparent, highly light-transmitting plastic commonly known as "acrylic." The following proprietary names are or were in frequent use: ACRYLITE®, Acryloid, Altuglas, *Crystalite*, DEGLAS®, *Diakon*, Kallodent, *Lucite*, Lumacryl, *Oroglas*, *Perspex*, Piacryl, PLEXIGLAS®, PLEXIGUM®, Shinkolite, Sumipex, *Vedril*, Vitredil.

Tensile strength This designates the resistance of a material to tensile forces. The tensile strength is stated as the ratio between the tensile force and the cross-sectional surface of the test specimen (unit of measurement e. g. N/mm^2).

Units of measurement
m = meter (unit of length)
s = second (unit of time)
g = gram (unit of mass)
N = newton (unit of force, 1 N = 1 kg · m/s^2)
J = joule (unit of energy, 1 J = 1 Nm)

Körperverträglichkeit

Während des Zweiten Weltkriegs machte ein englischer Augenarzt eine faszinierende Entdeckung: Einem seiner Patienten, einem Bomberpiloten, war bei einem Angriff ein Acrylglassplitter seiner eigenen Flugzeugkanzel ins Auge geraten. Erstaunlicherweise hatte der Splitter jedoch – anders als bei einem Holz- oder Metallteilchen – keine Entzündung verursacht. Damit war klar, dass das organische Acrylglas vom Immunsystem des menschlichen Körpers nicht abgestoßen wird, was dem Material neue, vornehmlich medizinische Anwendungsgebiete eröffnete. Frühe Haftschalen zur Korrektur von Sehfehlern und die ersten künstlichen Linsen, die gegen fortschreitende Erblindung verwendet wurden, bestanden beispielsweise aus PMMA. Auch zur Befestigung von Hüftgelenkprothesen, als Basismaterial im Dentalbereich, für Inkubatoren, Transfusionsgeräte und Sanitärobjekte aller Art wird der Werkstoff eingesetzt. Acrylglas besitzt an dieser Stelle den weiteren Vorteil, dass Bakterien deutlich weniger gut an ihm haften als auf Porzellan, Edelstahl und Email, insbesondere nach mechanischer Beanspruchung im täglichen Gebrauch. Schließlich rufen Objekte aus PMMA auch ein angenehmeres Wärmeempfinden hervor als vergleichbare Gegenstände aus Glas, Keramik oder emailliertem Stahlblech, was vor allem im Solarien- und Sanitärbereich ein Pluspunkt ist.

Physiological Compliance

During World War II, a British eye specialist made a fascinating discovery. One of his patients, a bomber pilot, had a sliver of acrylic go into his eye during an air raid. Amazingly, the sliver did not cause inflammation, as would have been the case with wood or metal fragments. This showed that the human immune system does not reject acrylic, and opened up new applications for the material in the field of medicine. Early contact lenses to correct refractive errors and the first intraocular lenses for cataract patients were made of PMMA. The material was also used to implant artificial hip joints, as a base material in orthodontics, for incubators, transfusion equipment and sanitary items of all descriptions. In these applications, acrylic has the further advantage that bacteria find it more difficult to adhere to than porcelain, stainless steel and enamel, particularly after being subjected to mechanical stress in everyday use. And finally, PMMA items are much more pleasant and warmer to the touch than comparable items made of glass, ceramics or enameled sheet steel, which is a definite bonus in tanning beds and bathrooms.

Verzeichnis der Exponate
List of Exhibits

Größenangaben: H × B × T | Size: H × W × D

Cat. 1
Armband, Deutschland, 1935 | Bracelet, Germany, 1935
Klares Polymethylmethacrylat (PMMA), graviert, grünes Leder | Clear polymethyl methacrylate (PMMA), engraved, green leather
H. 2 cm, Ø 7 cm
Kunststoff-Museums-Verein (KMV) e. V., Düsseldorf
Inv. K-2002-00467

Cat. 2
Parsifaltaube, 1936 | "Parsifal" dove, 1936
Klares Polymethylmethacrylat (PMMA) | Clear polymethyl methacrylate (PMMA)
17 × 79 × 38 cm
Bayreuther Festspiele GmbH

Cat. 3
Uhr „Elco", 1936/40 | Clock "Elco," 1936/40
Klares und beigefarbenes Polymethylmethacrylat (PMMA), Metall | Clear and beige-colored polymethyl methacrylate (PMMA), metal
19,5 × 17,8 × 7,5 cm
Hersteller | Manufacturer: Elco Clocks, London, United Kingdom
Kunststoff-Museums-Verein (KMV) e. V., Düsseldorf
Inv. K-1992-00195

Cat. 4
Goldmedaille der Weltausstellung in Paris, 1937 | Gold medal at World's Fair in Paris, 1937
Gold | Gold
H. 0,7 cm, Ø 7,7 cm
Röhm GmbH, Darmstadt

Cat. 5
Gartensessel, 1937 | Garden chair, 1937
Smaragdgrünes Polymethylmethacrylat (PMMA), Stahl, weiß lackiert | Emerald green polymethyl methacrylate (PMMA), steel, coated white
73,5 × 75 × 98 cm
Entwurf | Design: Jacques André, Jean Prouvé
Hersteller | Manufacturer: Ateliers Jean Prouvé, Nancy, France
Collection Eric Touchaleaume, Paris

Cat. 6
Violine, um 1937 | Violin, ca. 1937
Klares Polymethylmethacrylat (PMMA) | Clear polymethyl methacrylate (PMMA)
58,8 × 16,9 × 9,2 cm
Röhm GmbH, Darmstadt

Cat. 7
Radiogerät mit zwei Lautsprechern, Großbritannien, um 1938 | Radio set with two speakers, United Kingdom, ca. 1938
Rosafarbenes und schwarzes Polymethylmethacrylat (PMMA) | Pink and black polymethyl methacrylate (PMMA)
Radio | Radio 21 × 22 × 16 cm; Lautsprecher | Speaker 11,5 × 11 × 8 cm
Koelsch Collection · Germany, Essen
Inv. 9.3293

Cat. 8
Tablett, Großbritannien, um 1938 | Tray, United Kingdom, ca. 1938
Schwarzes und resedafarbenes Polymethylmethacrylat (PMMA) | Black and off-white polymethyl methacrylate (PMMA)
2 × 31,5 × 19 cm
Koelsch Collection · Germany, Essen
Inv. 4.1574

Cat. 9
Briefständer, Frankreich, um 1938 | Letter stand, France, ca. 1938
Klares und schwarzes Polymethylmethacrylat (PMMA), Metall | Clear and black polymethyl methacrylate (PMMA), metal
18 × 15,5 × 5 cm
Koelsch Collection · Germany, Essen
Inv. 6.3398

Cat. 10
Schale mit Standfuß, Deutschland, Ende 30er Jahre | Bowl with stand, Germany, late 1930s
Klares Polymethylmethacrylat (PMMA), graviert, Silberfassung | Clear polymethyl methacrylate (PMMA), engraved, silver rim
H. 7,5 cm, Ø 20 cm
Dr. Günter Lattermann, Bayreuth
Inv. Lat 0868

Cat. 11
Schale, Deutschland, Ende 30er Jahre | Bowl, Germany, late 1930s
Klares Polymethylmethacrylat (PMMA), Silberfassung | Clear polymethyl methacrylate (PMMA), silver trim
3,5 × 27,5 × 17 cm
Dr. Günter Lattermann, Bayreuth
Inv. Lat 0526

Cat. 12
Schale, Deutschland, Ende 30er Jahre | Bowl, Germany, late 1930s
Dunkel-rotbraunes Polymethylmethacrylat (PMMA) | Dark red-brown polymethyl methacrylate (PMMA)
H. 8 cm, Ø 30 cm
Dr. Günter Lattermann, Bayreuth
Inv. Lat 1125

Cat. 13
Brosche, Deutschland, Ende 30er Jahre | Brooch, Germany, late 1930s
Klares Polymethylmethacrylat (PMMA), graviert und weiß hinterlegt, Metall | Clear polymethyl methacrylate (PMMA), engraved with a white background, metal
4,5 × 4,5 × 1 cm
Dr. Günter Lattermann, Bayreuth
Inv. Lat 0703

Cat. 14
Brosche, Deutschland, Ende 30er Jahre | Brooch, Germany, late 1930s
Klares Polymethylmethacrylat (PMMA), graviert, Metall | Clear polymethyl methacrylate (PMMA), engraved, metal
1 × 8 × 1,5 cm
Dr. Günter Lattermann, Bayreuth
Inv. Lat 0717

Cat. 15
Paar Ohrringe, Deutschland, Ende 30er Jahre | Pair of earrings, Germany, late 1930s
Klares Polymethylmethacrylat (PMMA), Metall | Clear polymethyl methacrylate (PMMA), metal
H. 1 cm, Ø 6 cm
Dr. Günter Lattermann, Bayreuth
Inv. Lat 1040

Cat. 16
Armreif, Deutschland, Ende 30er Jahre | Bangle, Germany, late 1930s
Klares Polymethylmethacrylat (PMMA) | Clear polymethyl methacrylate (PMMA)
H. 1,5 cm, Ø 9 cm
Dr. Günter Lattermann, Bayreuth
Inv. Lat 1039

Cat. 17
Hutnadel, Deutschland, Ende 30er Jahre | Hat pin, Germany, late 1930s
Klares Polymethylmethacrylat (PMMA), Metall | Clear polymethyl methacrylate (PMMA), metal
L. 16 cm
Dr. Günter Lattermann, Bayreuth
Inv. Lat 0511

Cat. 18
Sägemesser, Deutschland, Ende 30er Jahre | Serrated knife, Germany, late 1930s
Klares Polymethylmethacrylat (PMMA), graviert | Clear polymethyl methacrylate (PMMA), engraved
L. 19 cm
Dr. Günter Lattermann, Bayreuth
Inv. Lat 1104

Cat. 19
Sägemesser, Deutschland, Ende 30er Jahre | Serrated knife, Germany, late 1930s
Klares Polymethylmethacrylat (PMMA), graviert | Clear polymethyl methacrylate (PMMA), engraved
L. 19 cm
Dr. Günter Lattermann, Bayreuth
Inv. Lat 1146

Cat. 20
Spargelheber, Deutschland, Ende 30er Jahre | Asparagus server, Germany, late 1930s
Klares Polymethylmethacrylat (PMMA), graviert | Clear polymethyl methacrylate (PMMA), engraved
3 × 10 × 21 cm
Dr. Günter Lattermann, Bayreuth
Inv. Lat 1148

Cat. 21
Kuchengabeln, Deutschland, Ende 30er Jahre | Cake forks, Germany, late 1930s
Klares Polymethylmethacrylat (PMMA), graviert | Clear polymethyl methacrylate (PMMA), engraved
L. 16 cm
Dr. Günter Lattermann, Bayreuth
Inv. Lat 1147

Cat. 22
Serviettenringe, Deutschland, Ende 30er Jahre | Napkin rings, Germany, late 1930s
Klares Polymethylmethacrylat (PMMA) | Clear polymethyl methacrylate (PMMA)
4 × 5 × 3 cm
Dr. Günter Lattermann, Bayreuth
Inv. Lat 1107

Cat. 23
Schreibset, Frankreich, Ende 30er Jahre | Writing set, France, late 1930s
Klares und opakes Polymethylmethacrylat (PMMA) in verschiedenen Farben | Clear and opaque polymethyl methacrylate (PMMA) in various colors
Platte | Plate 4 × 16 × 7,5 cm; Tintenfässer | Inkwells H. 4,5 cm, Ø 5,5 cm
Dr. Günter Lattermann, Bayreuth
Inv. Lat 0514

Cat. 24
Zwei Anstecker in Zikadenform, Frankreich, Ende 30er Jahre | Two small brooches shaped like cicadas, France, late 1930s
Polymethylmethacrylat (PMMA) in verschiedenen Farben, Metall | Polymethyl methacrylate (PMMA) in different colors, metal
2,5 × 8 × 1 cm; 2,5 × 6 × 2 cm
Dr. Günter Lattermann, Bayreuth
Inv. Lat 0512; Lat 0513

Cat. 25
Anstecker in Libellenform, Frankreich, Ende 30er Jahre | Small brooch shaped like a dragonfly, France, late 1930s
Polymethylmethacrylat (PMMA) in verschiedenen Farben, Metall | Polymethyl methacrylat (PMMA) in various colors, metal
2,5 × 5,5 × 1 cm
Dr. Günter Lattermann, Bayreuth
Inv. Lat 0515

Cat. 26
Brosche, Frankreich, Ende 30er Jahre | Brooch, France, late 1930s
Klares Polymethylmethacrylat (PMMA), graviert und weiß hinterlegt, Metall | Clear polymethyl methacrylate (PMMA), engraved with a white background, metal
H. 1 cm, Ø 5 cm
Dr. Günter Lattermann, Bayreuth
Inv. Lat 0660

Cat. 27
Damenhandtasche, Ende 30er Jahre | Ladies' handbag, late 1930s
Elfenbeinfarbenes opakes Polymethylmethacrylat (PMMA), Metall | Opaque ivory-colored polymethyl methacrylate (PMMA), metal
1,5 × 19,5 × 14,5 cm
Dr. Günter Lattermann, Bayreuth
Inv. Lat 1159

Cat. 28
Schatulle, Ende 30er Jahre | Casket, late 1930s
Klares und dunkelbraun-opakes Polymethylmethacrylat (PMMA) | Clear and opaque dark-brown polymethyl methacrylate (PMMA)
5,5 × 13 × 9 cm
Dr. Günter Lattermann, Bayreuth
Inv. Lat 1012

Cat. 29
Schatulle, Ende 30er Jahre | Casket, late 1930s
Klares Polymethylmethacrylat (PMMA), Metall | Clear polymethyl methacrylate (PMMA), metal
4,4 × 13,8 × 9 cm
Röhm GmbH, Darmstadt

Cat. 30
Kosmetik-Tablett mit zwei Dosen, Frankreich, um 1940 | Cosmetics tray with two jars, France, ca. 1940
Schwarzes und rosafarbenes opakes Polymethylmethacrylat (PMMA) | Opaque black and pink polymethyl methacrylate (PMMA)
Tablett | Tray 2,5 × 32 × 16,5 cm; Dosen | Jars 6 × 10,5 × 10,5 cm
Koelsch Collection · Germany, Essen
Inv. 3.2554 O/A/B

Cat. 31
Klapp-Zigarettendose, Frankreich, um 1940 | 4-compartment cigarette box with hinged lid, France, ca. 1940
Schwarzes und hellgrünes opakes Polymethylmethacrylat (PMMA) | Opaque black and light green polymethyl methacrylate (PMMA)
8 × 15 × 11,5 cm
Koelsch Collection · Germany, Essen
Inv. 7².1556

Cat. 32
Klappdose, Frankreich, um 1940 | Folding case, France, ca. 1940
Blaues und schwarzes opakes Polymethylmethacrylat (PMMA) | Opaque blue and black polymethyl methacrylate (PMMA)
10,5 × 19 × 12,5 cm
Koelsch Collection · Germany, Essen
Inv. 3.1518

Cat. 33
Serviettenringe, Frankreich, um 1940 | Napkin rings, France, ca. 1940
Rosé- und resedafarbenes opakes Polymethylmethacrylat (PMMA) | Opaque pale pink and off-white polymethyl methacrylate (PMMA)
4 × 4,5 × 5,5 cm
Koelsch Collection · Germany, Essen
Inv. 4.3411°+A

Cat. 34
Abendschuh, 1941 | Evening shoe, 1941
Klares und rotes Polymethylmethacrylat (PMMA), rotes Leder | Clear and red polymethyl methacrylate (PMMA), red leather
13 × 7,5 × 22 cm
Entwurf | Design: Frankfurter Modeamt
Hersteller | Manufacturer: Anton Pelz
Historisches Museum Frankfurt

Cat. 35
Drei Armreifen, um 1946 | Three bangles, ca. 1946
Klares Polymethylmethacrylat (PMMA) aus Flugzeugproduktion, graviert, farbig hinterlegt | Clear polymethyl methacrylate (PMMA) from aircraft material, engraved, with colored background
H. 2 cm, Ø 7,2 cm; H. 2,5 cm, Ø 7 cm; H. 1,5 cm, Ø 7,5 cm
Röhm GmbH, Darmstadt; Koziol »ideas for friends GmbH, Erbach

Cat. 36
Zwei Broschen, um 1946 | Two brooches, ca. 1946
Klares Polymethylmethacrylat (PMMA) aus Flugzeugproduktion, graviert, farbig hinterlegt, Metall | Clear polymethyl methacrylate (PMMA) from aircraft material, engraved, with colored background, metal
4 × 8 × 1 cm; 1 × 7,5 × 1,5 cm
Koziol »ideas for friends GmbH, Erbach

Cat. 37
Musikautomat Wurlitzer, Modell 1100, 1948 | Wurlitzer jukebox, model 1100, 1948
Klares Polymethylmethacrylat (PMMA), Holz, Metall | Clear polymethyl methacrylate (PMMA), wood, metal
146 × 78 × 65 cm
Entwurf | Design: Paul Fuller
Hersteller | Manufacturer: Rudolph Wurlitzer Company, North Tonawanda / N.Y., USA
Sammlung Gauselmann – Deutsches Automatenmuseum, Espelkamp

Cat. 38
Beauty-Bag, USA, 40er Jahre | Beauty bag, USA, 1940s
Klares Polymethylmethacrylat (PMMA), Metall | Clear polymethyl methacrylate (PMMA), metal
23,5 × 21,5 × 12 cm
Koelsch Collection · Germany, Essen
Inv. 5.2788

Cat. 39
Beauty-Bag, USA, 40er Jahre | Beauty bag, USA, 1940s
Metallisch gefärbtes Polymethylmethacrylat (PMMA), Metall | Metallic-colored polymethyl methacrylate (PMMA), metal
21 × 22 × 11 cm
Koelsch Collection · Germany, Essen
Inv. 5.2459

Cat. 40
Teil einer Flugzeugkanzel, 40er Jahre | Part of an aircraft canopy, 1940s
Klares Polymethylmethacrylat (PMMA) | Clear polymethyl methacrylate (PMMA)
47,5 × 54 × 14,5 cm
Koziol »ideas for friends GmbH, Erbach

Cat. 41
Zwei Rasierer, um 1950 | Two razors, ca. 1950
Klares Polymethylmethacrylat (PMMA) | Clear polymethyl methacrylate (PMMA)
8,5 × 4 × 2,5 cm
Röhm GmbH, Darmstadt

Cat. 42
Messerschmitt Kabinenroller KR 200, 1955/56 | Messerschmitt microcar KR 200, 1955/56
Haube aus klarem Polymethylmethacrylat (PMMA) | Canopy made of clear polymethyl methacrylate (PMMA)
130 × 128 × 285 cm
Entwurf | Design: Fritz Fend
Hersteller | Manufacturer: Messerschmitt, Regensburg, Deutschland
Fam. Breuninger, Stuttgart

Cat. 43
Butterdose, 1955/56 | Butter dish, 1955/56
Klares Polymethylmethacrylat (PMMA), Edelstahl | Clear polymethyl methacrylate (PMMA), stainless steel
5,5 × 22 × 10 cm
Entwurf | Design: Wilhelm Wagenfeld
Hersteller | Manufacturer: WMF, Geislingen, Deutschland
Koelsch Collection · Germany, Essen
Inv. 4.2694A

Cat. 44
Phonosuper SK 4 („Schneewittchensarg"), 1956 | Phonosuper SK 4 ("Snow White's coffin"), 1956
Abdeckung aus klarem Polymethylmethacrylat (PMMA), Holz, Metall, weiß lackiert | Cover made of clear polymethyl methacrylate (PMMA), wood, metal, coated white
24,5 × 58,5 × 29 cm
Entwurf | Design: Hans Gugelot, Dieter Rams, Wilhelm Wagenfeld
Hersteller | Manufacturer: Braun AG, Frankfurt a. M., Deutschland
Institut für Neue Technische Form, Darmstadt

Cat. 45
Tischleuchte, 1957 | Table lamp, 1957
Milchigweißes Polymethylmethacrylat (PMMA) | Milky white polymethyl methacrylate (PMMA)
36,5 × 22,5 × 18 cm
Entwurf | Design: Hanns Hoffmann-Lederer
Hersteller | Manufacturer: Endemann GmbH, Friedrichshafen, Deutschland
Institut für Neue Technische Form, Darmstadt

Cat. 46
Wandleuchte, 1957 | Wall lamp, 1957
Milchigweißes Polymethylmethacrylat (PMMA) | Milky white polymethyl methacrylate (PMMA)
52 × 20 × 7,5 cm
Entwurf | Design: Hanns Hoffmann-Lederer
Kunststoff-Museums-Verein (KMV) e. V., Düsseldorf
Inv. K-1992-00476

Cat. 47
Mechanische Mokkamühle mit abnehmbarer Kurbel, 1957 | Mechanical mocca mill with detachable crank, 1957
Pinkfarbenes Polymethylmethacrylat (PMMA), eloxiertes Aluminium | Pink polymethyl methacrylate (PMMA), anodized aluminum
H. 14 cm, Ø 5,5 cm
Werksentwurf | Factory design
Hersteller | Manufacturer: VEB Schnittwerkzeuge- und Metallwarenfabrik Klingenthal, DDR
Sammlung Höhne Berlin

Cat. 48
Sessel „Lily", um 1958 | Armchair "Lily," ca. 1958
Klares Polymethylmethacrylat (PMMA), Polster | Clear polymethyl methacrylate (PMMA), with cushion
94,2 × 74,5 × 84 cm
Entwurf | Design: Estelle Laverne, Erwine Laverne
Hersteller | Manufacturer: Laverne International Inc., New York, USA
Vitra Design Museum, Weil am Rhein
Inv. E MUS-1117

Cat. 49
Deckenleuchte, 50er Jahre | Ceiling lamp, 1950s
Klares Polymethylmethacrylat (PMMA), Metall | Clear polymethyl methacrylate (PMMA), metal
H. 74 cm, Ø 43 cm
Entwurf | Design: Wolfgang Tümpel
Hersteller | Manufacturer: Carl W. Kopperschmidt & Co., Hamburg, Deutschland
Museum für Kunst und Gewerbe Hamburg
Inv. 2007.080

Cat. 50
Salatbesteck, 50er Jahre | Salad servers, 1950s
Klares Polymethylmethacrylat (PMMA), Silber | Clear polymethyl methacrylate (PMMA), silver
L. 25 cm
Entwurf | Design: Wolfgang Tümpel
Privatbesitz | Privately owned

Cat. 51
Bilderrahmen, 50er Jahre | Picture frame, 1950s
Klares Polymethylmethacrylat (PMMA) | Clear polymethyl methacrylate (PMMA)
22 × 17 × 2,5 cm
Koziol »ideas for friends GmbH, Erbach

Cat. 52
Werbeschild „Wella", 50er Jahre | "Wella" advertising sign, 1950s
Klares und schwarzes Polymethylmethacrylat (PMMA) | Clear and black polymethyl methacrylate (PMMA)
H. 3,5 cm, Ø 22 cm
Röhm GmbH, Darmstadt

Cat. 53
Präsentationsobjekt für Damenstrümpfe, 50er Jahre | Mannequin leg for displaying ladies' stockings, 1950s
Opakes Polymethylmethacrylat (PMMA) | Opaque polymethyl methacrylate (PMMA)
H. 73,3 cm, Ø 11,5 cm
Röhm GmbH, Darmstadt

Cat. 54
Automobilheckleuchte, Ende 50er Jahre | Automotive taillight cluster, late 1950s
Polymethylmethacrylat (PMMA) in verschiedenen Farben | Polymethyl methacrylate (PMMA) in various colors
48 × 9,8 × 11,3 cm
Röhm GmbH, Darmstadt

Cat. 55
Magnettonbandgerät BG 26, 1963 | BG 26 tape recorder, 1963
Abdeckung aus klarem Polymethylmethacrylat (PMMA), Metall | Cover made of clear polymethyl methacrylate (PMMA), metal
13,5 × 41 × 26,5 cm
Entwurf | Design: Ekkehard Bartsch
Hersteller | Manufacturer: VEB Meßgerätewerk Zwönitz, DDR
Sammlung Höhne Berlin

Cat. 56
Halskette, 1965 | Necklace, 1965
Gelbes und weißes Polymethylmethacrylat (PMMA) | Yellow and white polymethyl methacrylate (PMMA)
36 × 17 cm
Entwurf | Design: Hermann Jünger
Caroline Geisler, Mühltal

Cat. 57
Tischleuchte „Satellite", 1965 | "Satellite" table lamp, 1965
Klares Polymethylmethacrylat (PMMA), Metall verchromt | Clear polymethyl methacrylate (PMMA), chrome-plated metal
41 × 40 × 26,5 cm
Entwurf | Design: Yonel Lebovici
Die Neue Sammlung – Staatliches Museum für angewandte Kunst | Design in der Pinakothek der Moderne, München
Inv. 205/95

Cat. 58
Bodenleuchte „Globo Tissurato", 1966/67 |
"Globo Tissurato" floor lamp, 1966/67
Klares Polymethylmethacrylat (PMMA),
Metall, weiß lackiert | Clear polymethyl
methacrylate (PMMA), metal, coated white
H. 70 cm, Ø 40 cm
Entwurf | Design: Ugo La Pietra
Hersteller | Manufacturer: Zama
Elettronica, Poggi (Pavia), Italia
Vitra Design Museum, Weil am Rhein
Inv. E MLA-1009

Cat. 59
Tischleuchte "Gherpe", 1967 |
"Gherpe" table lamp, 1967
Weißes Polymethylmethacrylat (PMMA),
Metall | White polymethyl methacrylate
(PMMA), metal
37 × 31,5 × 43,5 cm
Entwurf | Design: Superstudio (= Gian
Piero Frassinelli, Alessandro Magris,
Roberto Magris, Adolfo Natalini, Cristiano
Toraldo di Francia)
Hersteller | Manufacturer: Poltronova s.r.l.,
Agliana (Pistoia), Italia
Die Neue Sammlung – Staatliches Museum
für angewandte Kunst | Design in der
Pinakothek der Moderne, München
Inv. 118/96

Cat. 60
Hängesessel „Bubble Chair", 1968 |
"Bubble Chair," 1968
Klares Polymethylmethacrylat (PMMA),
Stahl verchromt, Lederpolster | Clear
polymethyl methacrylate (PMMA), chrome-
plated steel, leather upholstery
76,5 × 107 × 106,5 cm
Entwurf | Design: Eero Aarnio
Hersteller | Manufacturer: Asko, Lahti,
Suomi
Vitra Design Museum, Weil am Rhein
Inv. E MSK-1171

Cat. 61
Einrichtungselemente der „Tunnel-
Discoteca", Hotel Grifone, Bozen, 1968 |
Furnishing elements of the "Tunnel-
Discoteca," Hotel Grifone, Bozen, 1968
Klares und grünes Polymethylmeth-
acrylat (PMMA), Metall, Stoffpolster |
Clear and green polymethyl methacrylate
(PMMA), metal, fabric upholstery
Stühle | Chairs 66 × 46 × 45 cm; Hocker |
Stool H. 42 cm, Ø 41 cm; Tisch | Table
H. 59 cm, Ø 70 cm; Wandpaneele |
Wall panels 140 × 152 cm, 130 × 187 cm
Entwurf | Design: Cesare Casati,
Emmanuele Ponzio, Gino Marotta
Hersteller | Manufacturer: Guzzini &
Comfort, Italia
Die Neue Sammlung – Staatliches Museum
für angewandte Kunst | Design in der
Pinakothek der Moderne, München
Inv. 526/98

Cat. 62
Tischleuchte „Cespuglio di Gino", 1968 |
"Cespuglio di Gino" table lamp, 1968
Neongrünes Polymethylmethacrylat
(PMMA), Aluminium, Keramik, weiß
lackiert | Fluorescent green polymethyl
methacrylate (PMMA), aluminum, ceramic,
coated white
H. 32 cm, Ø 41 cm
Entwurf | Design: Ennio Lucini
Hersteller | Manufacturer: Guzzini
Design House, Recanati, Italia
Die Neue Sammlung – Staatliches Museum
für angewandte Kunst | Design in der
Pinakothek der Moderne, München
Inv. 416/94

Cat. 63
Baukasten, 1968 | Building blocks, 1968
Klares Polymethylmethacrylat (PMMA),
mit Koffer | Clear polymethyl
methacrylate (PMMA), with case
Würfelkante | Cube edge 6–18 cm;
Koffer | Case 43 × 31 × 8 cm
Entwurf | Design: Waki Zöllner
Hersteller | Manufacturer: Waki Zöllner,
München, Deutschland
Die Neue Sammlung – Staatliches Museum
für angewandte Kunst | Design in der
Pinakothek der Moderne, München
Inv. 90/68

Cat. 64
Fernsehgerät „Black ST 201", 1969 |
"Black ST 201" television set, 1969
Gehäuse aus schwarzem Polymethyl-
methacrylat (PMMA) | Housing of black
polymethyl methacrylate (PMMA)
25 × 31 × 29,5 cm
Entwurf | Design: Marco Zanuso,
Richard Sapper
Hersteller | Manufacturer: Brionvega,
Milano, Italia
Koelsch Collection · Germany, Essen
Inv. 9.3298

Cat. 65
Deckenleuchte Nr. 16705 „VP-Globe",
1969/70 | Ceiling lamp No. 16705
"VP-Globe," 1969/70
Klares Polymethylmethacrylat (PMMA),
Aluminium, z.T. farbig lackiert und ver-
chromt | Clear polymethyl methacrylate
(PMMA), aluminum, partially with color
coating and chrome plating
Ø 60 cm
Entwurf | Design: Verner Panton
Hersteller | Manufacturer: Louis
Poulsen & Co. A/S, København, Danmark
Vitra Design Museum, Weil am Rhein
Inv. E MLA-1059-1

Cat. 66
Tischleuchte „Mezzachimera", 1969/70 |
"Mezzachimera" table lamp, 1969/70
Milchigweißes Polymethylmethacrylat
(PMMA) | Milky white polymethyl
methacrylate (PMMA)
77 × 22 × 22 cm
Entwurf | Design: Vico Magistretti
Hersteller | Manufacturer: Artemide S.p.A.,
Pregnana Milanese, Italia
Städtische Kunstsammlung Darmstadt

Cat. 67
Manuelle Bleistiftanspitz-Maschine
„Asis", Mitte 60er Jahre | Manual pencil
sharpener machine "Asis," mid-1960s
Auffangbehälter aus blauem Polymethyl-
methacrylat (PMMA), Korpus Aluminium-
guss, Hammerschlaglack | Shavings box
made of blue polymethyl methacrylate
(PMMA), body of cast aluminum, hammer
dimple enamel
11,5 × 7,5 × 12 cm
Werksentwurf | Factory design
Hersteller | Manufacturer: VEB Fein-
werktechnik Leipzig, DDR
Sammlung Höhne Berlin

Cat. 68
Spiegel „Ultrafragola", 1970 |
"Ultrafragola" mirror, 1970
Farbiges Polymethylmethacrylat (PMMA),
Spiegel | Colored polymethyl methacrylate
(PMMA), mirror
195 × 100 × 13 cm
Entwurf | Design: Ettore Sottsass
Hersteller | Manufacturer: Poltronova s.r.l.,
Agliana (Pistoia), Italia
Poltronova

Cat. 69
Schachspiel, 1970 | Chess set, 1970
Schwarzes und weißes opakes Polymethylmethacrylat (PMMA) | Opaque black and white polymethyl methacrylate (PMMA)
Kasten | Box 34,5 × 21 × 10 cm
Entwurf | Design: Vera Röhm
Hersteller | Manufacturer: Röhm GmbH, Darmstadt, Deutschland
Vera Röhm, Darmstadt

Cat. 70
Souvenir Maxi-Kugelschreiber „Fernsehturm Berlin", um 1970 | Jumbo ballpoint pen souvenir "Fernsehturm Berlin," ca. 1970
Sichtfenster aus klarem Polymethylmethacrylat (PMMA), blaues Duroplast | Window of clear polymethyl methacrylate (PMMA), blue thermoset
L. 20,5 cm
Hersteller | Manufacturer: VEB Heiko Wernigerode, DDR
Sammlung Höhne Berlin

Cat. 71
Tonmöbel „Vision 2000", 1971 | "Vision 2000" audio cabinet, 1971
Abdeckung aus klarem Polymethylmethacrylat (PMMA), Metall verchromt | Cover of clear polymethyl methacrylate (PMMA), chrome-plated metal
H. 90 cm, Ø 60 cm
Entwurf | Design: Thilo Oerke
Hersteller | Manufacturer: Rosita Tonmöbel, Schloss Neuhaus, Deutschland
Design-Sammlung der Bergischen Universität Wuppertal
Inv. BUGH0022

Cat. 72
Drei Badezimmer-Hocker, 1971 | Three bathroom stools, 1971
Schwarzes, hellblaues und mittelblaues opakes Polymethylmethacrylat (PMMA) | Opaque black, light blue and medium blue polymethyl methacrylate (PMMA)
40 × 68 × 36 cm
Entwurf | Design: Vera Röhm
Hersteller | Manufacturer: Röhm GmbH, Darmstadt, Deutschland
Vera Röhm, Darmstadt

Cat. 73
Andenkenplakette zum Richtfest des Olympia-Lichtdaches, 1972 | Plaque commemorating topping-out ceremony, Olympic Stadium roof, 1972
Braunes Polymethylmethacrylat (PMMA), graviert | Brown polymethyl methacrylate (PMMA), engraved
8,8 × 8,8 × 0,4 cm
Röhm GmbH, Darmstadt

Cat. 74
Wecker „25 Jahre DDR", 1974 | Alarm clock "25 Jahre DDR," 1974
Klares Polymethylmethacrylat (PMMA), Metall | Clear polymethyl methacrylate (PMMA), metal
9 × 8 × 7,5 cm
Gardé Uhren und Feinmechanik Ruhla GmbH, Uhrenmuseum

Cat. 75
Zettelkasten, Werbemittel für Radio DDR, 70er Jahre | File-card box, giveaway for Radio DDR, 1970s
Klares und orangefarbenes Polymethylmethacrylat (PMMA) | Clear and orange polymethyl methacrylate (PMMA)
4,5 × 13 × 10 cm
Sammlung Höhne Berlin

Cat. 76
Experimenteller Stuhl (Entwicklungsmodell), 1982 | Experimental chair (development model), 1982
Klares Polymethylmethacrylat (PMMA) | Clear polymethyl methacrylate (PMMA)
83 × 44,5 × 59 cm
Entwurf | Design: Verner Panton
Hersteller | Manufacturer: Dansk Acryl Teknik, Danmark
Vitra Design Museum, Weil am Rhein
Inv. E MPA-1078

Cat. 77
Stuhl „Teodora", 1986 | "Teodora" chair, 1986
Klares Polymethylmethacrylat (PMMA), Holz, weiß und grau laminiert | Clear polymethyl methacrylate (PMMA), wood, laminated white and gray
85 × 57 × 56,5 cm
Entwurf | Design: Ettore Sottsass
Hersteller | Manufacturer: Vitra AG, Basel, Schweiz
Vitra Design Museum, Weil am Rhein
Inv. E MIT-1020-1

Cat. 78
Raumteiler „Fish 'n Chips", 1988 | Partition "Fish 'n Chips," 1988
Klares Polymethylmethacrylat (PMMA) mit Metalleinschlüssen, Aluminium, Gummi | Clear polymethyl methacrylate (PMMA) with metal inclusions, aluminum, rubber
140 × 225 cm
Entwurf | Design: Ad Us Berlin (= Manuel Pfahl, Bettina Wiegandt)
Prototyp | Prototype
Staatliche Museen zu Berlin, Kunstgewerbemuseum
Inv. 1992, 23

Cat. 79
Klarinette, 1988 | Clarinet, 1988
Klares Polymethylmethacrylat (PMMA), Metall | Clear polymethyl methacrylate (PMMA), metal
L. 67,6 cm
Hersteller | Manufacturer: W. Schreiber & Söhne GmbH, Nauheim, Deutschland
Röhm GmbH, Darmstadt

Cat. 80
Thermoskanne „Basic", 1991 | "Basic" thermos flask, 1991
Klares, azurblaues, flaschengrünes, lavarotes oder anthrazitfarbenes Polymethylmethacrylat (PMMA) | Clear, sky blue, bottle green, lava red or anthracite polymethyl methacrylate (PMMA)
21 × 17 × 19 cm
Entwurf | Design: Julian Brown, Ross Lovegrove
Hersteller | Manufacturer: alfi GmbH, Wertheim, Deutschland
Alfi

Cat. 81
Käsereibe „Parmenide", 1994 | Cheese grater "Parmenide," 1994
Blaues, rotes oder eierschalfarbenes Polymethylmethacrylat (PMMA), Edelstahl | Blue, red or eggshell-colored polymethyl methacrylate (PMMA), stainless steel
6,7 × 7,5 × 15,3 cm
Entwurf | Design: Alejandro Ruiz
Hersteller | Manufacturer: Alessi S.p.A., Crusinallo, Italia
Museo Alessi

Cat. 82
Drei Zierkorken, 90er Jahre |
Three decorative stoppers, 1990s
Gelbes, blaues und rotes Polymethylmethacrylat (PMMA), Gummi | Yellow, blue and red polymethyl methacrylate (PMMA), rubber
11,5 × 7 × 2 cm; 11,5 × 5 × 2 cm; 11,5 × 7,5 × 2 cm
Hersteller | Manufacturer: Koziol ideas for friends GmbH, Erbach, Deutschland
Koziol »ideas for friends GmbH, Erbach

Cat. 83
Vier Serviettenringe, 90er Jahre |
Four napkin rings, 1990s
Klares, rotes und gelbes Polymethylmethacrylat (PMMA) | Clear, red and yellow polymethyl methacrylate (PMMA)
H. 1,5 cm, Ø 8 cm; 1,5 × 8 × 9 cm; H. 1,5 cm, Ø 7,5 cm; 1,5 × 7 × 7,5 cm
Hersteller | Manufacturer: Koziol ideas for friends GmbH, Erbach, Deutschland
Koziol »ideas for friends GmbH, Erbach

Cat. 84
Sektkühler, 90er Jahre | Champagne cooler, 1990s
Violettes Polymethylmethacrylat (PMMA) | Purple polymethyl methacrylate (PMMA)
28 × 23 × 21,5 cm
Hersteller | Manufacturer: Koziol ideas for friends GmbH, Erbach, Deutschland
Koziol »ideas for friends GmbH, Erbach

Cat. 85
Schale, 90er Jahre | Bowl, 1990s
Gelbes Polymethylmethacrylat (PMMA) | Yellow polymethyl methacrylate (PMMA)
H. 3,5 cm, Ø 27,5 cm
Hersteller | Manufacturer: Koziol ideas for friends GmbH, Erbach, Deutschland
Koziol »ideas for friends GmbH, Erbach

Cat. 86
Topfuntersetzer, 90er Jahre | Trivet, 1990s
Blaues Polymethylmethacrylat (PMMA) | Blue polymethyl methacrylate (PMMA)
1,5 × 17 × 13,5 cm
Hersteller | Manufacturer: Koziol ideas for friends GmbH, Erbach, Deutschland
Koziol »ideas for friends GmbH, Erbach

Cat. 87
Chaiselongue „LCP", 2000 | Chaise longue "LCP," 2000
Klares, himmelblaues, pinkfarbenes oder neongelbes Polymethylmethacrylat (PMMA), Metall | Clear, sky blue, pink or fluorescent yellow polymethyl methacrylate (PMMA), metal
64,1 × 48,6 × 96,8 cm
Entwurf | Design: Maarten van Severen
Hersteller | Manufacturer: Kartell S.p.A., Noviglio, Italia
Kartell, Milano – funktion möbel + galerie gerhard wolf gmbh, Darmstadt

Cat. 88
Stuhl „Rainbow", 2000 |
Chair "Rainbow," 2000
Polymethylmethacrylat (PMMA) in verschiedenen Farben | Polymethyl methacrylate (PMMA) in various colors
80,2 × 39 × 47 cm
Entwurf | Design: Patrick Norguet
Hersteller | Manufacturer: Cappellini International Interiors s.n.c. die Capellini Enrico & C., Carugo, Italia
Die Neue Sammlung – Staatliches Museum für angewandte Kunst | Design in der Pinakothek der Moderne, München
Inv. 733/2002

Cat. 89
Hocker/Tischchen „La Bohème 1", 2000 |
Stool-cum-coffee table "La Bohème 1," 2000
Klares, gelbes, flaschengrünes, veilchenfarbenes oder rotes Polymethylmethacrylat (PMMA) | Clear, yellow, bottle green, violet or red polymethyl methacrylate (PMMA)
H. 46 cm, Ø 30 cm
Entwurf | Design: Philippe Starck
Hersteller | Manufacturer: Kartell S.p.A., Noviglio, Italia
Röhm GmbH, Darmstadt

Cat. 90
Eisbecher „Big Love", 2002 | Sundae glass "Big Love," 2002
Blaues, fuchsiarotes, orangefarbenes oder grünes Polymethylmethacrylat (PMMA), Edelstahl | Blue, fuchsia pink, orange or green polymethyl methacrylate (PMMA), stainless steel
H. 15 cm, Ø 12 cm
Entwurf | Design: Mirriam Mirri
Hersteller | Manufacturer: Alessi S.p.A., Crusinallo, Italia
Museo Alessi

Cat. 91
Sonnenliege „Rainbow" Modell 1006, 2005 | Sun lounger "Rainbow" model 1006, 2005
PLEXIGLAS SATINICE® Geflecht in Regenbogenfarben, Aluminium | Woven PLEXIGLAS SATINICE® in rainbow colors, aluminum
120 × 82 × 195 cm
Entwurf | Design: Barbara Crettaz
Hersteller | Manufacturer: Creation Crettaz GmbH, Lichtenfels, Deutschland
Creation Crettaz GmbH, Lichtenfels (www.creation-crettaz.de)

Cat. 92
Leuchte „Brindille luminaire", 2006 |
Lamp "Brindille luminaire," 2006
Klares Polymethylmethacrylat (PMMA) optische Glasfaser | Clear polymethyl methacrylate (PMMA) fiber optics
H. 250 cm, Ø 90 cm
Entwurf | Design: François Azambourg
Hersteller | Manufacturer: Roset S.A., Briord, France
Roset Möbel GmbH

Cat. 93
Containerkubus „Optic" mit und ohne Tür, 2006 | Container cube "Optic" with and without door, 2006
Klares, gelbes, veilchenfarbenes, rotes, fuméfarbenes oder mattschwarzes Polymethylmethacrylat (PMMA) | Clear, yellow, violet, red, smoke-colored or matte black polymethyl methacrylate (PMMA)
40 × 40 × 40 cm
Entwurf | Design: Patrick Jouin
Hersteller | Manufacturer: Kartell S.p.A., Noviglio, Italia
Kartell, Milano – funktion möbel + galerie gerhard wolf gmbh, Darmstadt

Die Leihgeber der Ausstellung
Lenders of the Exhibition

Alfi GmbH, Wertheim
Matthias Jessberger

Bayreuther Festspiele GmbH, Bayreuth
Stephan Jöris

Familie Breuninger, Stuttgart

Creation Crettaz GmbH, Lichtenfels
Barbara Crettaz, Marcel Crettaz

Design-Sammlung der Bergischen
Universität Wuppertal
Prof. Dr. Gerda Breuer

Collection Eric Touchaleaume, Paris

Gardé Uhren und Feinmechanik Ruhla
GmbH, Uhrenmuseum, Ruhla
Artur Kamp

Caroline Geisler, Mühltal

Historisches Museum, Frankfurt am Main
Dr. Jan Gerchow, Dr. Wolfgang Cilleßen

Institut für Neue Technische Form,
Darmstadt
Michael Schneider

Kartell, Milano – funktion möbel + galerie
gerhard wolf gmbh, Darmstadt
Gerhard Wolf

Koelsch Collection · Germany, Essen
Hans-Ulrich Kölsch

Koziol »ideas for friends GmbH, Erbach
Katrin Bode

Kunststoff-Museums-Verein e.V.,
Düsseldorf
Ellen Kreutz, Uta Scholten

Dr. Günter Lattermann, Bayreuth

Museo Alessi, Omegna
Francesca Appiani

Museum für Kunst und Gewerbe
Hamburg
Prof. Dr. Wilhelm Hornborstel,
Dr. Rüdiger Joppien

Die Neue Sammlung – Staatliches Museum für angewandte Kunst | Design in der
Pinakothek der Moderne, München
Prof. Dr. Florian Hufnagl, Dr. Josef Straßer

Poltronova, Montale
Francesca Balena Arista

Röhm GmbH, Darmstadt

Vera Röhm, Darmstadt

Roset Möbel GmbH, Gundelfingen
Sabine Walter-Böhm, Ines Bühler

Sammlung Gauselmann – Deutsches
Automatenmuseum, Espelkamp
Monika Kokoska

Sammlung Höhne Berlin
Günter Höhne

Staatliche Museen zu Berlin, Kunstgewerbemuseum
Dr. Angela Schönberger, Dr. Susanne Netzer

Vitra Design Museum, Weil am Rhein
Boguslaw Franciszek Ubik-Perski

sowie eine Privatsammlung, die nicht
namentlich genannt werden möchte
and a private collection that prefers not to
be mentioned

Der Autor Kai Buchholz dankt ferner
folgenden Personen für wertvolle
Unterstützung und fachlichen Rat
The author Kai Buchholz would further like
to thank the following people for their
valuable support and professional advice

Eero Aarnio, Veikkola, Suomi

Helge Aszmoneit, Rat für Formgebung,
Frankfurt am Main

Stefan S. Handt, Sindelfingen

Dr. Günter Lattermann, Bayreuth

Ross Lovegrove, London

Katja Miksovsky, MAK – Österreichisches
Museum für angewandte Kunst/Gegenwartskunst, Wien

Eva Wittig, Tim Warneke, RAG Service
GmbH, Standortarchiv Darmstadt

Personenregister
Index of Names

Kursiv gesetzte Seitenzahlen verweisen auf Abbildungen | Page numbers in italics refer to illustrations

Aarnio, Eero (*1932) 69, 70, 72, *82*, 145
Ad Us (= Manuel Pfahl, *1958 | Bettina Wiegandt, *1957) 102, *110*, 146
Aicher, Otl (1922–1991) 72
Albus, Volker (*1949) 102
Andersen, Hans Christian (1805–1875) 113
André, Jacques 21, 22, *26*, *38/39*
Azambourg, François (*1963) 117, *134*, 147

Baj, Enrico (1924–2003) 13, 14
Bartsch, Ekkehard (*1934) *65*, 144
Behnisch, Günter (*1922) *76/77*
Böhme, Gernot (*1937) 116, 122
Borngräber, Christian (1945–1992) 102
Brando, Marlon (1924–2004) 98, 100
Brandolini, Andreas (*1951) 102
Brown, Julian (*1955) *135*, 146

Calatrava, Santiago (*1951) 116
Candela, Félix (1910–1997) 116
Casati, Cesare (*1936) *84/85*, 145
Cook, Peter (*1936) *120*, *121*, 121
Crettaz, Barbara (*1964) 117, *133*, 147

De Lucchi, Michele (*1951) 97, 98
Dylan, Bob (= Robert Zimmermann, *1941) 97, 98

Fend, Fritz (1920–2000) 45, *46*, *60/61*, 143
Fournier, Colin (*1944) *120*, *121*, 121
Fuller, Paul (1899–1952) 47, 50, *63*, 143

Gabo, Naum (= Nehumia Pevsner, 1890–1977) 13, 14
Geddes, Norman Bel (1893–1958) 22, 25
Gloag, John (1896–1981) 18, 19, 21, 22
Graves, Michael (*1934) 97, 98
Gugelot, Hans (1920–1965) 54, *64*, 144

Hoffmann-Lederer, Hanns (1899–1970) 51, 53, 54, *58*, 144
Hörl, Ottmar (*1950) *112*

Itten, Johannes (1888–1967) 53

Jackson, Lorin 18, 19
Janssen, Matthias 72, 75, *78*, *79*, 79
Jouin, Patrick (*1967) *128*, 147
Jünger, Hermann (1928–2005) 144

Kagan, Vladimir (*1927) 70
Kazan, Elia (1909–2003) 98, 100
Kubrick, Stanley (1928–1999) 72
Kufus, Axel (*1958) 102
Kuramata, Shiro (1934–1991) 98, 100, 101, *109*

La Pietra, Ugo (*1938) 71, *90*, 145
Laubersheimer, Wolfgang (*1955) 102
Laverne, Erwine (1909–2003) 53, 54, *59*, 144
Laverne, Estelle (1915–1998) 53, 54, *59*, 144
Lebovici, Yonel (1937–1998) 71, *83*, 144
Leigh, Vivien (1913–1967) 98, 100
Loewy, Raymond (1893–1986) 22, 25
Lovegrove, Ross (*1958) 117, 120, 122, *135*, 146
Lucini, Ennio (*1934) 71, *87*, 145

Magistretti, Vico (1920–2006) 71, 72, 145
Marotta, Gino (*1935) *84/85*, 145
Marx, Karl (1818–1883) 105
Medgyès, Ladislas (*1892) *16*, 18, 19
Meikle, Jeffrey L. (*1949) 47
Messerschmitt, Willy (1898–1978) 45
Mirri, Mirriam (*1964) 147
Moholy-Nagy, László (1895–1946) 51
Mortellito, Domenico (1906–1994) 22

Norguet, Patrick (*1969) 117, *129*, 147

Oerke, Thilo (*1940) *92*, 146
Opaschowski, Horst W. (*1941) 123
Otto, Frei (*1925) 72, *76/77*

Panton, Verner (1926–1998) 70, 71, *91*, *111*, 145, 146
Pasquier, Nathalie du (*1957) 97, 98
Ponzio, Emmanuele (*1923) *84/85*, 145
Prouvé, Jean (1901–1984) 21, 22, *26*, 27, 28, *38/39*, 141

Rams, Dieter (*1932) 54, *64*, 144
Röhm, Otto (1876–1939) 7, 17, 18
Röhm, Vera (*1943) 13, 14, *89*, 146
Rubinstein, Helena (1870–1965) *16*, 18, 19, *26*
Ruiz, Alejandro (*1954) *134*, 146
Ruskin, John (1819–1900) 105

Sapper, Richard (*1932) 71, 72, *93*, 145
Severen, Maarten van (1956–2005) 113, 114, 117, *126/127*, 147
Silvestrin, Danilo (*1942) 70
Sottsass, Ettore (*1917) 88, 97, *108*, 145, 146
Starck, Philippe (*1949) 113, 114, *130/131*, 147
Superstudio (= Adolfo Natalini, *1941 | Cristiano Toraldo di Francia, *1941 | Roberto Magris, *1935 | Gian Piero Frassinelli, *1939 | Alessandro Magris, *1941) 71, 72, *86*, 145

Thun, Matteo (*1952) 97, 98
Tümpel, Wolfgang (1903–1978) 50, 51, 53, *62*, *66*, 144

Velde, Henry van de (1863–1957) 19, 22

Wagenfeld, Wilhelm (1900–1990) *64*, 67, 143, 144
Wagner, Winifred (1897–1980) 17, 18
Williams, Tennessee (1911–1983) 98, 100

Yokoyama, Tadashi 98, 102

Zanuso, Marco (1916–2001) 71, 72, *93*, 145
Zöllner, Waki (*1935) 145

Foto- und Bildnachweis
Photo and Image Credits

Fotonachweis | Photo Credits

Adelta: 82

Alessi: 132

Alfi GmbH: 135

Archiv Mühlbauer: 46

Archives, Museum of Science and Industry, Chicago: 52

C. Baraja/E. Touchaleaume. Archives Eric Touchaleaume: 26 (unten | below), 38/39

Bayreuther Festspiele GmbH: 30/31

Familie Breuninger, Stuttgart: 60/61

Joachim Clüsserrath, Köln: 92

Creation Crettaz GmbH: 133

Stephan Eichler, Wuppertal: 91

Getty Images/Time & Life Pictures/Herbert Gehr: 26 (oben | above)

Fotodesign Hefele, Darmstadt: 32/33, 34/35, 36, 37, 40, 42/43, 58, 64, 67 (oben | above), 89, 93

Historisches Museum Frankfurt/Horst Ziegenfusz: 41

Günter Höhne, Berlin: 65, 67 (unten | below), 94/95

Kartell: 126/127, 128, 130/131, (Umschlag | Cover)

Idris Kolodziej, Berlin: 110

Ligne Roset: 134

Museum Huelsmann, Bielefeld/Axel Grünewald: 66

Museum für Kunst und Gewerbe Hamburg: 62

Die Neue Sammlung – Staatliches Museum für angewandte Kunst | Design in der Pinakothek der Moderne, München/A. Bröhan, München: 83, 84/85, 86, 87

Die Neue Sammlung – Staatliches Museum für angewandte Kunst | Design in der Pinakothek der Moderne, München/A. Laurenzo, Die Neue Sammlung: 129

Poltronova: 88

Röhm GmbH, Darmstadt: 2, 10, 12, 19, 20, 21, 23, 25, 44, 47, 48/49, 50, 51, 55, 68, 70, 73, 74, 75, 76/77, 78, 79, 99, 100, 101, 103, 104, 105, 112, 115, 116, 118/119, 120, 121, 123, 136, 140, 148

Sammlung Gauselmann – Deutsches Automatenmuseum, Espelkamp: 63

Monika Schürle, Berlin: 114

Vitra Design Museum, Weil am Rhein: 59, 90, 108, 109, 111

Bildnachweis | Image Credits

Andrea DiNoto: Art Plastic. Designed for Living. New York 1984: 16

Modern Plastics. 19 (1942), Heft/Issue 8: 6, 24

Modern Plastics. 26 (1948), Heft/Issue 3: 9

Röhm Spektrum. 33 (1985): 96

© VG Bild-Kunst, Bonn 2007, für | for Yonel Lebovici, Jean Prouvé, Vera Röhm, Wilhelm Wagenfeld

Trotz sorgfältiger Recherche war es nicht in allen Fällen möglich, die Rechteinhaber zu ermitteln. Berechtigte Ansprüche werden selbstverständlich im Rahmen der üblichen Vereinbarungen abgegolten.

Despite careful research it was not always possible to ascertain the holder of the rights in every case. Compensation for justified claims will be made on the scale of customary agreements.

Dieses Katalogbuch erscheint anlässlich der Ausstellung
This catalogue is published in conjunction with the exhibition

PLEXIGLAS®
Werkstoff in Architektur und Design
Material in Architecture and Design

Institut Mathildenhöhe Darmstadt
Museum Künstlerkolonie

16. 09. 2007 – 06. 01. 2008

Direktor | Director: Ralf Beil

Ausstellung | Exhibition

Institut Mathildenhöhe

Gesamtleitung | Direction: Ralf Beil

Kurator | Curator: Kai Buchholz

Kuratorische Mitarbeit | Curatorial Assistance: Renate Ulmer

Koordination | Coordination: Annette Windisch

Sekretariat | Secretary's Office: Angelika Nitsch

Presse- und Öffentlichkeitsarbeit | Press and Public Relations
Lina Ophoven-Armey

Restauratorin | Restoration: Susanne Leydag

Ausstellungsdesign | Exhibition Design: Christian Häussler

Aufbau und Technik | Construction and Technology
Uwe Brückner, Hartmut Kani, Karl-Heinz Köth, Alfred Lücker,
Jürgen Preusch

Administration | Administration: Ulli Emig, Michael Heine

Werbemedien | Advertising Media
BECKER SPÄTH Konzept und Design

Institut Mathildenhöhe
Olbrichweg 13
64287 Darmstadt
Tel. +49 6151 13-2778
Fax +49 6151 13-3739
www.mathildenhoehe.eu

Röhm GmbH, Darmstadt

Projektleitung | Project Management
Franziska Linné

Ausstellungskoordination | Exhibition Coordination
Wilfried Tammen

Röhm GmbH
Kirschenallee
64293 Darmstadt
Tel. + 49 6151 18-01
Fax. + 49 6151 18-02

Katalog | Catalogue

Herausgeber | Editor: Ralf Beil

Redaktion | Editing: Ralf Beil, Kai Buchholz

Redaktionelle Mitarbeit | Editing Assistance
Institut Mathildenhöhe: Annette Windisch
Röhm GmbH: Rudolf Blass, Doris Hirsch, Jürgen Jourdan,
Ulrich Kläres, Franziska Linné, Eva Wittig

Verlagskoordination | Production Editing: Christine Linder

Lektorat | Copy Editing: Petra Böttcher

Gestaltung und Satz | Design and Typeset: WIGEL

Übersetzung | Translation
RAG Service GmbH, Sprachendienst | Language Services
Mitzi Morgan, Lautertal

Gesamtherstellung | Printed by
Wienand Verlag & Medien GmbH

Umschlagabbildung | Cover Image
Philippe Starck, La Bohème 1–3, 2000/01

© 2007 Institut Mathildenhöhe Darmstadt, Wienand Verlag &
Medien GmbH, Köln, Kai Buchholz, Röhm GmbH, Darmstadt

Erschienen im | Published by
Wienand Verlag & Medien GmbH
www.wienand-verlag.de
ISBN 978-3-87909-925-2

Ausstellung und Katalog wurden ermöglicht durch
Exhibition and catalogue were realized with kind support of

degussa.
creating essentials

Medienpartner

hr2 kultur

PLEXIGLAS® ist eine registrierte Marke der Röhm GmbH, Darmstadt, Deutschland. Alle Marken sind im Text versal oder kursiv geschrieben. | PLEXIGLAS® is a registered trademark of Röhm GmbH, Darmstadt, Germany. All trademarks in the text are written in capitals or in italics.

Der Degussa Geschäftsbereich Methacrylates ist ein weltweit führender Hersteller von PMMA-Produkten. Diese werden in Europa, Asien, Afrika und Australien unter der Marke PLEXIGLAS® und in Nord- und Südamerika unter der Marke ACRYLITE® vertrieben. Degussa's Methacrylates Business Unit is a worldwide leading manufacturer of PMMA products, sold under the PLEXIGLAS® trademark on the European, Asian, African and Australian Continents and under the ACRYLITE® trademark in the Americas.